SECRET
BRENTWOOD

Michael Foley

AMBERLEY

To Carol and Kevin, special friends.
Thank you to Kyra Foley for the use of her photographs.

First published 2018

Amberley Publishing
The Hill, Stroud
Gloucestershire, GL5 4EP

www.amberley-books.com

Copyright © Michael Foley, 2018

The right of Michael Foley to be identified as the
Author of this work has been asserted in accordance
with the Copyrights, Designs and Patents Act 1988.

ISBN 978 1 4456 7817 7 (print)
ISBN 978 1 4456 7818 4 (ebook)

British Library Cataloguing in Publication Data.
A catalogue record for this book is available from the
British Library.

Origination by Amberley Publishing.
Printed in Great Britain.

Contents

Introduction

In the distant past it was the small village of South Weald that was the more important settlement in the area around what was to become Brentwood. It was mentioned in the Domesday Book and has a Norman church. The area originally known as Burnt Wood was only recorded later when pilgrims making their way to Canterbury, to the site of Thomas à Becket's murder, needed somewhere to stay. Their route bypassed South Weald. The travellers influenced the local people, and the chapel built in the town in 1221 was dedicated to Thomas à Becket.

Brentwood soon became synonymous with conflict. Henry III sent 300 soldiers to arrest Hubert de Burgh in 1232 when he was hiding in the chapel of Thomas à Becket in the town. Also, Brentwood was one of the first towns to experience the Peasants' Revolt, led by Wat Tyler in 1381.

There have been other attractions throughout Brentwood's history, such as a racecourse and large summer military camps at nearby Warley. Large crowds would gather to watch the sham battles put on by the soldiers, who often fought before royalty. The camps were eventually replaced by permanent barracks.

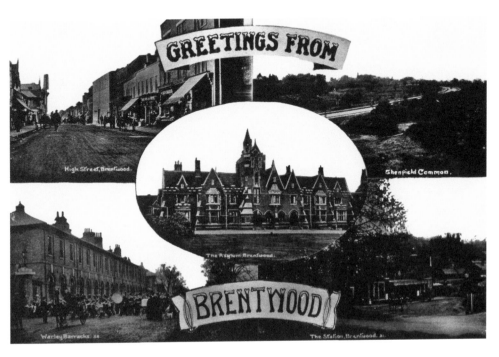

An old welcome to Brentwood card showing various images of the area.

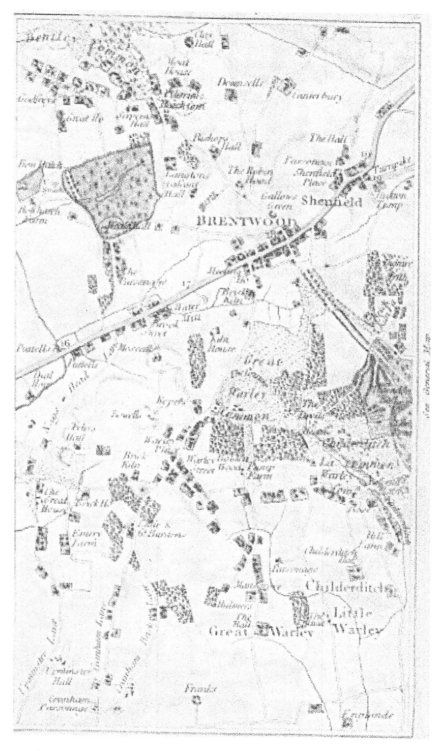

An old map from the late eighteenth century showing Brentwood as nothing more than a small village with one road.

The town of Brentwood is around 18 miles from London and stands on the road to Norwich. In the mid-nineteenth century it had a population of just over 2,000. In addition to those living in the town, there were around 400 inmates in the asylum at Warley, a similar number at the schools in the area, and around 1,000 men at the barracks at Warley. (The barracks were occupied at different periods by both the British Army and the forces of the East India Company.)

When the railway arrived in Brentwood in the mid-nineteenth century, the town began to grow around the station and the then separate village of Warley began to spread towards it, until the two places ultimately became indistinguishable.

People

Although mainly residential, there have been some notable industries in the area such as Ilford Photo (renowned manufacturers of photographic materials), the headquarters of Lord Alan Sugar's Amstrad company, and the first producers of trampolines in the United Kingdom.

Brentwood has become even more famous thanks to the reality television series *The Only Way is Essex*, whose filming locations include the Sugar Hut club and restaurant. The town has had a history of celebrity residents, although many of them lived here in their younger years. The ancient Brentwood School can boast former students as diverse as Noel Edmonds, Frank Lampard and Sir Robin Day.

Perhaps one of Brentwood's most famous inhabitants was William Hunter, who was burned as a heretic in 1555. The place he was burned is not where his memorial now stands, but was on part of Shenfield Common known as the Butts. It was where archery was practised and where sports such as bull-baiting and cockfighting took place. The area is now part of Brentwood Grammar School.

Hunter was a Protestant and was apprenticed to a silk weaver in London. His religious beliefs led to his dismissal and he came home to Brentwood. This was in the days of the

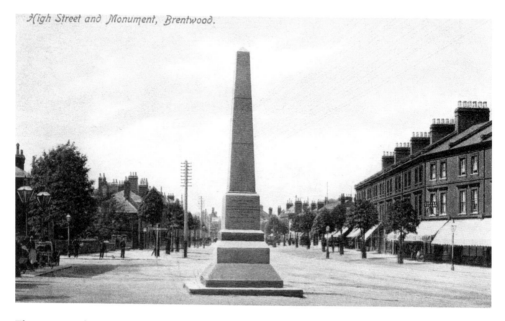

High Street and Monument, Brentwood.

The memorial to William Hunter, who was burnt in the town for heresy, shown in the early twentieth century.

Catholic queen Mary Tudor, when a person's religious choices could put them in danger. Reading the Bible in English was a right denied to the population but something that William Hunter believed he should be able to do.

Hunter was sent to appear before the Bishop of London, who tried to convert him. Hunter was only nineteen, and after a spell in Newgate Prison he was sent back to Brentwood for execution. He was burnt at the Butts. His monument was erected in 1861, paid for by local subscription.

Brentwood is far from the coast so it may come as a surprise that it has connections with the sea. Admiral John Jarvis, who lived in a house called Rocketts in South Weald, joined the Navy at fourteen. After he captured a 74-gun French ship in 1782 while commanding the HMS *Foudroyant*, he was made a knight and an admiral.

Rocketts was the property of Sir Thomas Parker and in 1783 Jarvis married Parker's daughter, who was also his cousin. When his father-in-law died the following year the house became theirs and was extended. Jarvis is best remembered for defeating a large Spanish fleet of twenty-seven ships with only fifteen of his own off Cape St Vincent, which resulted in Jarvis becoming the Earl of St Vincent.

After his retirement from naval life the Earl of St Vincent retired to Rocketts, but not to total obscurity. The social life at Rocketts must have been a revelation to the locals, with visitors including two kings, George IV and William IV. Even his great friend Nelson was a visitor to the house despite the earl's outspoken nature, which led to his criticism of Nelson's relationship with Lady Hamilton. After the earl's death the house became the property of one of the Coope family of Romford brewery fame.

The Hunter Memorial today, showing how the area around it has changed.

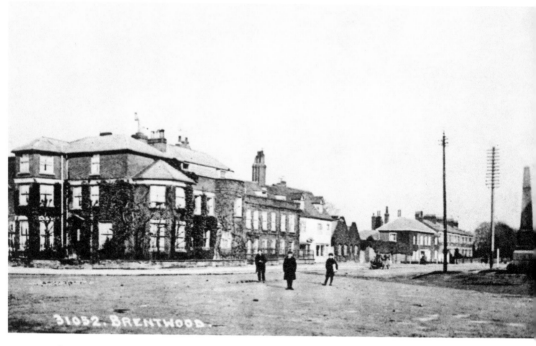

Another view of the Hunter Memorial (on the right), showing some of the older buildings that stood close by in the early twentieth century.

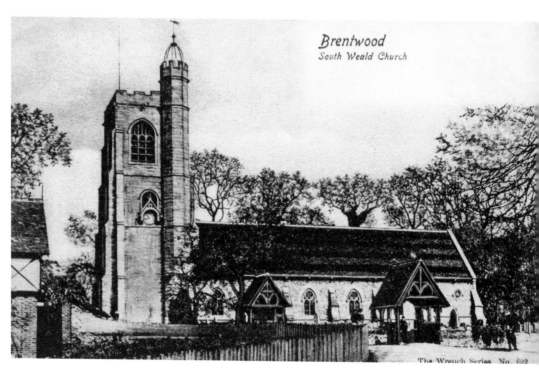

The church at South Weald where Admiral Jarvis fell out with the vicar.

DID YOU KNOW?

The Earl of St Vincent was so outspoken that he upset the local residents, and after an argument with the vicar he swore never to enter the parish church again. Jarvis died in 1823 and his promise about not entering the church was kept as he was buried in Staffordshire, his birthplace.

Brentwood seemed to be well provided with doctors in the mid-nineteenth century as there were four living in the High Street, which seems a large number for what was such a small town at the time. Perhaps the best remembered was Dr Cornelius Butler, who was from a family with a medical background – his father was a surgeon and one of his son-in-laws became a surgeon for the East India Company when they were based at Warley Barracks.

Butler is said to be the person who gave the town the news of the Battle of Waterloo in the courtyard of the White Hart Inn. Butler lived in Cockayne House on the corner of High Street and Warley Lane. He later lived in the red house almost opposite St Thomas' Church. Dr Butler would visit his patients on horseback and believed in bleeding them – a common practice at the time that involved withdrawing blood from a patient in order to prevent or cure illness.

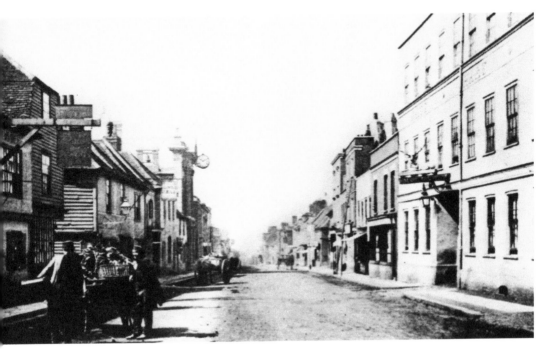

The old White Hart pub is on the right of the picture. The White Hart was once an important gathering place.

DID YOU KNOW?

The overseer of the Poor Law contracted a local doctor for the medical care of the poor. Competition for this contract was fierce in Brentwood, as there were four of them in the town. The doctors put in their bids and the lowest was accepted. Their duties included caring for the parish poor and those passing through the town.

Not all people were welcome in the town. In the late nineteenth century Shenfield Common was often used as a camping ground by gypsies. According to Larkin they were 'low-class gipsies' that had dirty canvas tents and half-starved animals. They had what Larkin called 'house carts', which were slept in by men and women while children and dogs slept underneath. The gypsies made it unsafe for women and children to walk on the common.

Another resident of Brentwood was the father of Cecil Rhodes, who had a huge influence on obtaining South Africa for the Empire – a controversial man in today's world. His father was the Revd Francis Rhodes, who once climbed on the roof of a burning building in the High Street to remove tiles so the water from the fire engine could reach the flames. If he had fallen through then his son may never have been born and the history of Africa may have been very different. The reverend left Brentwood for Bishop's Stortford.

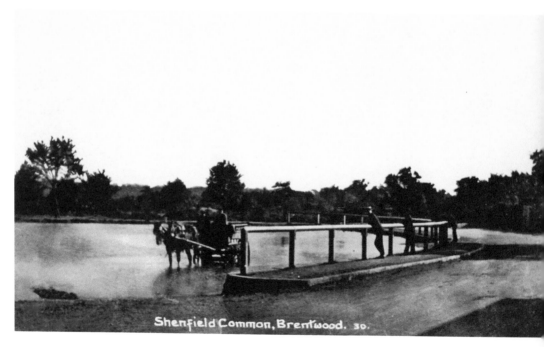

An old view of Shenfield Common, which was a local amenity for those driving a horse and cart.

Another old view of Shenfield Common. As well as being a drinking place for horses, it was also used by locals for picnics.

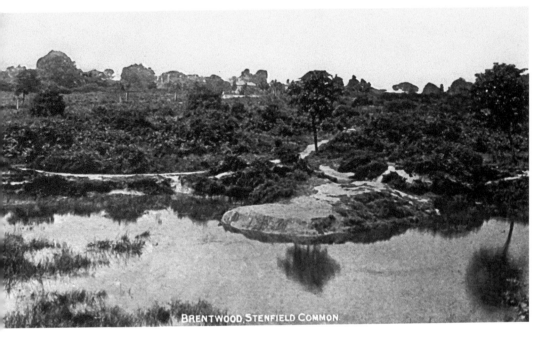

BRENTWOOD, STENFIELD COMMON.

A more rural view of Shenfield Common. Despite being popular with locals, it was sometimes used as a place to dump waste from the construction of the railway.

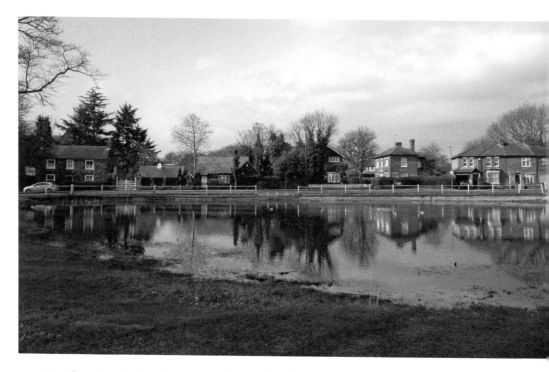

A modern view of Shenfield Common showing how the town has spread to the edges of the open land.

An unusual Brentwood resident of the early twentieth century was a man named Ole Oddy, a hermit who built himself a dugout at Warley Gap. He was described by Mrs Eva Carsnell, the landlady of the Brewery Tap, as being very unkempt and as smoking an old clay pipe upside down. He also wore an old overcoat that nearly touched the ground. Oddy would step on molehills and claimed that moles died if you touched their nose. He then dried the moleskins and sewed them onto his waistcoat.

He would come into the Brewery Tap every Saturday morning and put down threepence for a quart of beer in a pewter tankard – the pub had no glasses at that time. After drinking half his beer he would produce a rabbit from one of the many pockets in his old coat and offer it for sale for sixpence. Mrs Carsnell said that he would produce up to twelve rabbits at one time. Then when he had sold them all he would go to other public houses to sell more.

In August 1913 Lord and Lady Petre, the local aristocracy, returned from their honeymoon. They set about entertaining the cottagers, old people, tradespeople and tenant farmers on different days at Thorndon Hall, which was an old custom of the family. Lord Petre hoped to start reconstructing Thornden Hall and to live there among his tenant farmers.

Lord Petre told the farmers that the position of a great estate landlord was not as firm as it was thirty years before, but he hoped to bring it back to something like its former standing. He went on to say that agriculture was passing through a very troublesome time and he hoped it would survive. He was planning to do all in his power to maintain the cordial relations between landlord and tenants on the Thorndon estate.

Another of Brentwood's old public houses: the William IV and some of its old regulars.

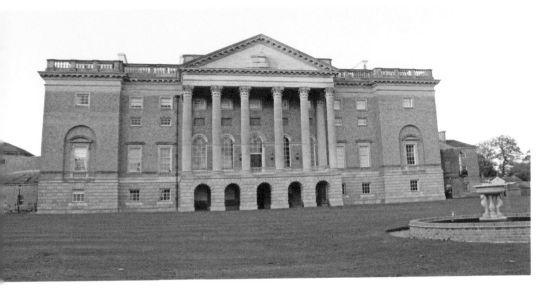

Thorndon Hall, for many years the home of the Petre family, now converted into apartments.
(Kyra Foley)

One of Brentwood's best-remembered residents was Ellen Willmott of Warley Place, who was known internationally for her garden. The garden of Warley Place had in fact been originally laid out by Humphrey Repton in 1806. The Willmots moved into the house in 1876. Ellen Wilmott filled her garden with rare plants, and these attracted numerous visitors including royalty.

By the beginning of the First World War she was suffering financially. The war, however, came as a blessing to her as some of her houses were used by soldiers, which gave her a supplementary income. Ellen died in 1934 and the house itself was demolished in 1939. The area is now a nature reserve.

In Brentwood in September 1919 there was a serious dispute in the town involving Mrs Angelina Gregory, a soldier's wife. She had been turned out of her house under an ejectment order. Her furniture was put in the road and a hostile crowd had gathered. Windows in four houses owned by Mrs Gregory's landlord were smashed. The landlord wanted the house for his daughter, who was a soldier's widow.

One of the more influential Brentwood residents of the twentieth century was Terence Blake, better known as Ted Blake. He wasn't born in Brentwood, but became involved in the town and in sport after he joined the Essex Regiment. He was based at Warley after transferring to the Army Physical Training Corps. The number two gymnasium of the barracks is one of the few buildings that still remain and is now known as Keys Hall.

He met his wife while at the barracks, who unusually was a female member of the Home Guard. After being demobbed Ted became a PE teacher and while working at

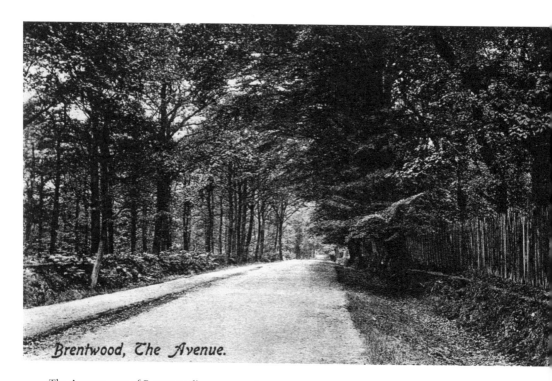

Brentwood, The Avenue.

The Avenue, one of Brentwood's many rural scenes.

A view of Keys Hall, which was once a gymnasium for Warley Barracks.

Another view of Keys Hall, now a council hall used by locals. It was once the home of a children's special needs charity that now resides in the grounds of the old asylum.

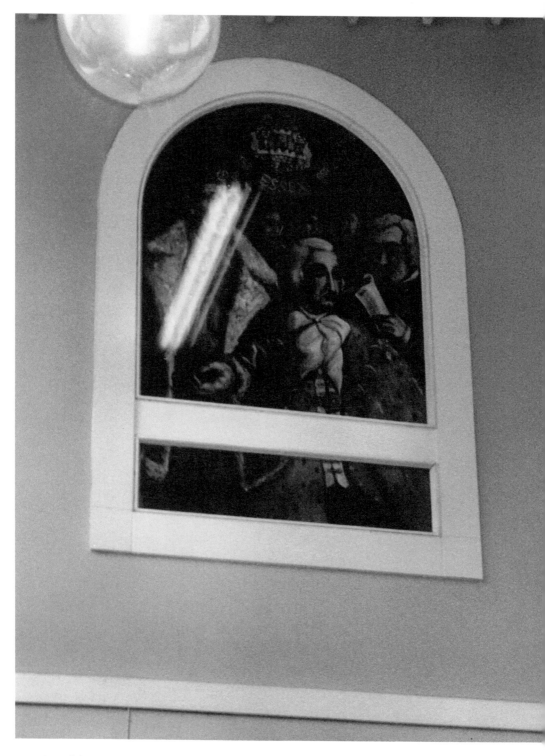

One of the interior windows of Keys Hall with images of the old camps at Warley that preceded the barracks.

Loxford School in Ilford he introduced trampolining. The new form of sport attracted a lot of attention and was featured in a Pathé News film in 1950.

The trampoline had been around for some time but was better known in America. Its development was mainly due to George Nissan, an American who got the idea from watching safety nets being used during circus acts. He built his first trampoline in 1934 and toured America performing at carnivals, before founding his first company making them in 1941. Trampolines were used to train American pilots during the Second World War, and after the success of this they began to be used as an aid to fitness. After the war Nissan began to tour in Europe.

Blake eventually persuaded Nissan to open a trampoline factory in England, which opened in Hainault, London, in 1956. Blake was attracting more attention now, and his own trampoline in his back garden in Manor Park, where he was then living, was featured in the *Daily Mirror* in 1957. The factory expanded to larger premises, first in Romford then to its final home on the Hutton Industrial Estate in Brentwood. In addition to working with his wife, Blake's son also began to help out, which led to an appearance on *Blue Peter* in the 1960s.

The publicity for Blake's trampolines was not always what would be seen as politically correct today. One article in the *World Sports Magazine* in 1959 had the headline 'Bed for Fat Boys'. In the article Blake said, 'one of the best things the trampoline has done is to make the class duffer - the fat boy gymnastics conscious. He may not be able to touch his

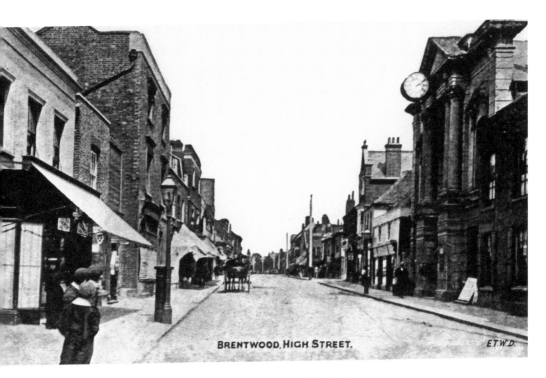

BRENTWOOD, HIGH STREET. E.T.W.D.

Another old view of the High Street, which leads towards Shenfield.

toes but after a few minutes bouncing he can do simple exercises.' Another factor that probably wasn't considered at the time was the advantages that trampolines could have for the disabled as well as those who were just 'class duffers'.

One local club did well out of the presence of the factory in Brentwood. Shenfield Trampoline Club was supplied with new trampolines, which were free. The club were given often new types of trampolines for testing – not always successfully.

The parent company of Nissan became concerned about lawsuits in the 1970s from people injured on trampolines and stopped production of them in America. The fear also reached Brentwood and the company eventually shut down in the mid-1980s, ending Brentwood's lead in the promotion of what had become a worldwide sport. Trampoline production did continue in Essex, however, with a new company run by former Nissan employees.

Schools and Buildings

Brentwood School has a long history dating back to the sixteenth century. It was founded by Sir Anthony Browne, a lawyer who owned a number of estates in Essex. The school has been in existence ever since, although a new building was opened in 1910, and there are a number of older buildings including a Victorian chapel. The school grounds cover 72 acres. The pupils there would have been the sons of farmers and local gentry and many went on to make a name for themselves. A number of the old boys died in the world wars and are commemorated in the school memorial. Although originally a boys' school, girls were permitted entry from 1974.

The National School for boys, another local school, opened in the church dedicated to St Thomas à Becket on the High Street. The chapel, as it was then, was built in 1221 and a few years later became the scene of national outrage when Hubert de Burgh, chief minister of Henry III, fell out with the king and went to his nephew's house in Brentwood. The king sent soldiers to arrest him, so he sought sanctuary in the chapel. The soldiers dragged him out and he was taken to the Tower of London. The king then relented and let him return to the chapel but posted guards and starved him out. He was returned to the Tower, and eventually forgiven and released.

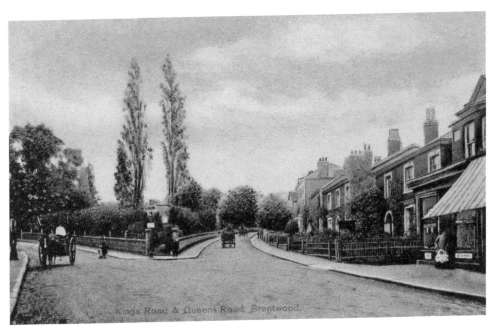

Queens Road where it joins with Kings Road. Queens Road leads to Brentwood School.

An old view of Brentwood School, which dates back hundreds of years.

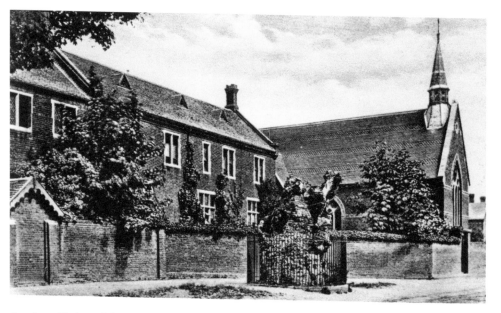

Another old view of Brentwood School, showing the chapel alongside it.

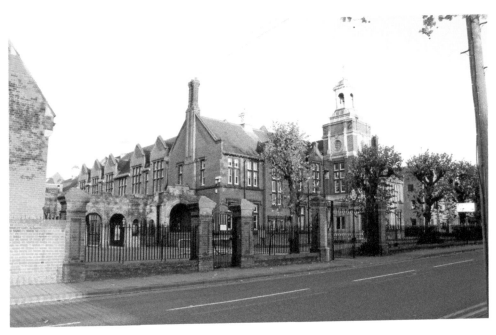

A modern image of the Brentwood School, which now permits girls to attend. (Kyra Foley)

In August 1577 the fate of the chapel aroused local anger when there were plans to demolish it. The sheriff of Essex, Wistan Browne, was called to the town because of a riot. Thirty spinsters led by Thomasine Tyler had surrounded the chapel. They had thrown out the schoolmaster Richard Brooke before locking themselves inside armed with pitchforks, a piked staff and bows and arrows. They were all arrested.

The problem was that Browne had inherited the chapel and was no longer willing to pay the £5 a year to the Brentwood chaplain, so had decided to demolish it. It seems that he had already removed all the seats inside the building, the bell and the clock. Three of the town's inhabitants had petitioned the Lord Chancellor over the matter. The Privy Council ordered that the women should be released from prison and only given small fines. The cause was seen to be Browne stopping the people of Brentwood from using the chapel.

There were further problems with the Browne family when in 1616 four of the town's inhabitants instituted a case against Sir Anthony Browne for not appointing a chaplain and taking the chaplain's house for his own use. Browne claimed that the chapel was a private building. He was told that a chaplain must be appointed. There were no militant women around to save the chapel in the nineteenth century and after a new church was built in the town the chapel was demolished leaving only part of the tower, which still survives today.

Another church was built in 1835 as the old one had become too small. It wasn't well built and part of the tower collapsed. It seems that it wasn't a very lucky church as the builder who was employed to erect it went bankrupt before it was complete. A new chancel was added in 1855, but by 1881 it was clear that a new building was needed, which was opened in 1883.

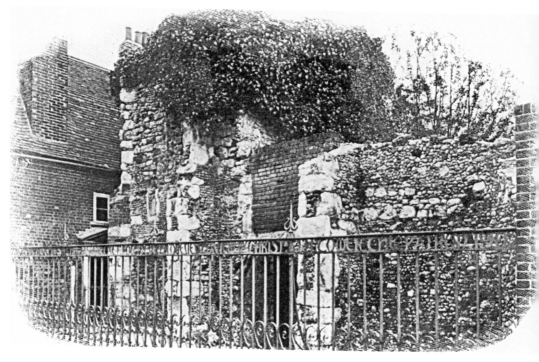

The ruins of the old chapel of St Thomas à Becket, which still survives today.

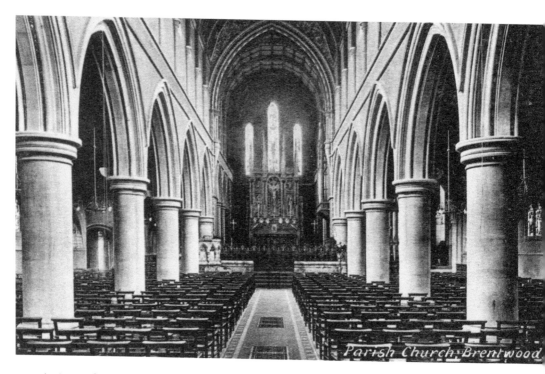

An internal view of the church.

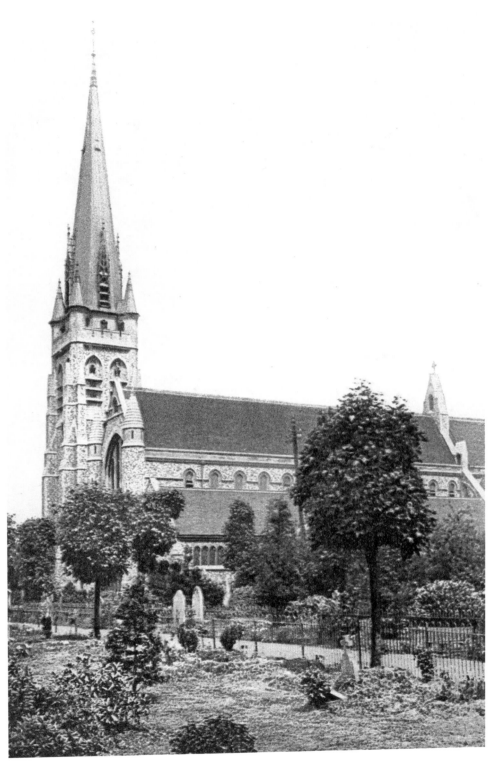

St Thomas', the parish church of Brentwood that was built to replace the old chapel.

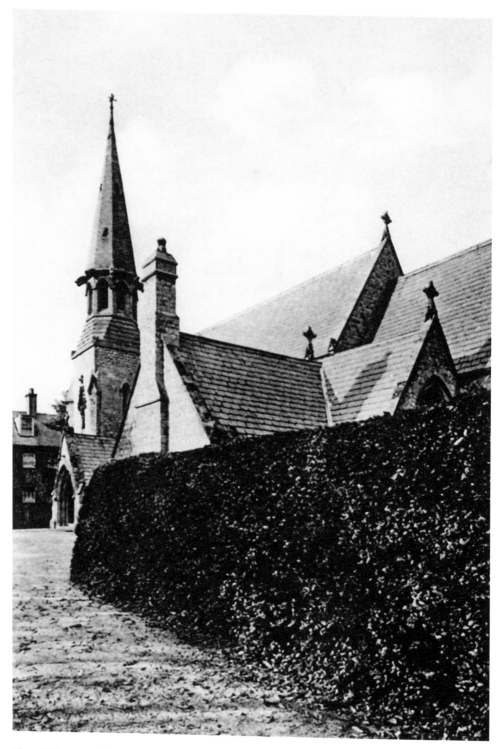

The old Roman Catholic church, which became a cathedral and often had a large congregation made up from the men based at the barracks.

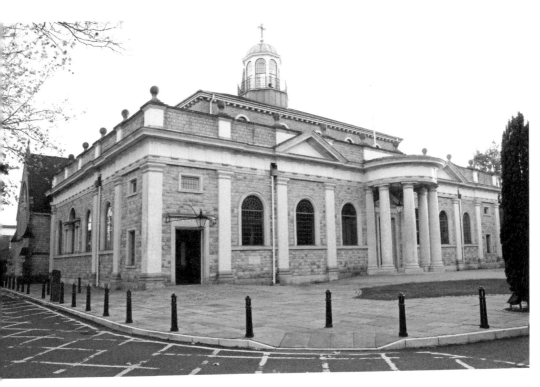

The new Roman Catholic cathedral built alongside the old church.

The religious strife between Catholics and Protestants is well remembered in Brentwood because of the fate of William Hunter, but by the mid-nineteenth century religious problems were less pronounced. The Petre family, who were important local people, were staunch Roman Catholics. Lord Petre gave land in Ingrave Road for the building of a Catholic church, and St Helen's was built. It was soon evident that it was not large enough, especially when many of the soldiers from the barracks attended Mass. It was replaced with a larger building in 1861 called Sacred Heart and St Helen's.

During the First World War it was decided that a new diocese was needed in Brentwood and Sacred Heart and St Helen's became a Roman Catholic cathedral. It was extended in the 1970s but – as seems to have been a repeating pattern with churches in the town – it became evident that there were serious problems with the building. A new church was built by 1991, but the building retained part of the 1861 building.

The Ophthalmia School at High Wood was the subject of a report in *The Times* in February 1911 regarding 'feeble-minded' children. Before this, such children under the age of sixteen and in the care of the Metropolitan Asylums Board had been maintained in small homes in London run by specially trained house mothers. In 1903 it was decided that these children could remain in care until they reached the age of twenty-one.

It had been decided by this time that the care of these children could be carried out in larger homes and the school in Brentwood had been used for older female children.

The children were now to be cared for in colonies rather than small homes. There was a suggestion that the children at Brentwood School would be moved to a larger colony at Darenth Asylum.

One of the large houses that stood in the town was Brentwood Hall. It was owned by a Mr Kavanagh in around 1840 and stood at the end of Kavanagh Lane, named after the hall owner himself. The building was later used as part of the Warley Asylum.

Mr Kavanagh sold 86 acres of his estate in 1849 to be used to build what was known as Warley Hospital. The building was completed and opened in 1853. It had been designed by H. E. Kendall and still looks frightening today, despite no longer being an asylum – what the patients in their poor mental state must have thought at first sight can only be imagined. Although some parts have been demolished, a large part of the original building remains as apartments.

The asylum at Warley is one example of how Brentwood took care of its less fortunate residents, but in the medieval period there was another local institution to care for the afflicted. This was a leper hospital that stood on a site at the end of Brook Street. The master's house stood where the Golden Fleece restaurant now stands and the hospital itself was where Spital Lane is situated.

In 1874 the Brentwood Industrial School was opened by the London School Board. Boys entered the school at six years of age and stayed until they were fifteen. Many of the

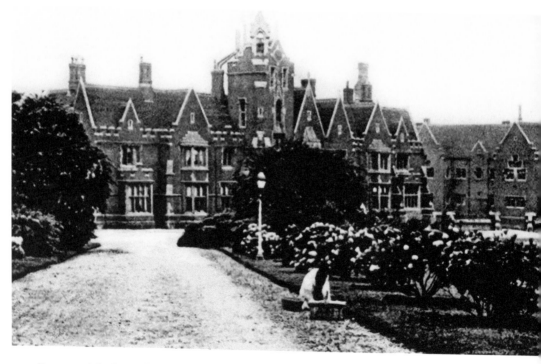

Brentwood Asylum, which was always an imposing-looking building. It has now been converted into apartments, with new housing built on the grounds.

Spital Lane, once the site of a leper hospital in the town.

children were said to be in very poor health when they arrived, but soon gained strength. By 1888, 330 boys had been admitted to the school and 225 had left. At a prize-giving in June 1888, Sir Ughtred Kay-Shuttleworth said he was very impressed at how the school had improved since he had visited six years before. He had nothing but praise for the men and women who ran the school.

It seems that whatever was seen at the prize-giving did not reflect the real events at the school. In May 1894 an extraordinary meeting of the school's guardians was called to consider the conduct of one of the guardians, Mr Pimlett. It was also to consider the allegations against the master and matron of the school Mr and Mrs Adwick. The allegations against Mr Pimlett, a former police superintendent, were that he assisted Mr Atkinson, a solicitor, in the defence of Nurse Gillespie. There had been serious allegations of cruelty against Nurse Gillespie. Both the master and matron had both denied any knowledge of the supposed brutality, but they allowed Gillespie to remain in the school for fourteen hours after she had been dismissed. They had been aware that she was hiding in the school when a warrant was issued for her arrest. They had then started a subscription on her behalf. The master and matron were suspended after it was claimed that considerable terrorism had been exercised over the children, who were to give evidence about the abuse.

Nurse Gillespie was eventually taken to court and later found guilty after she admitted a number of the charges against her. The judge was astounded that this cruelty could have

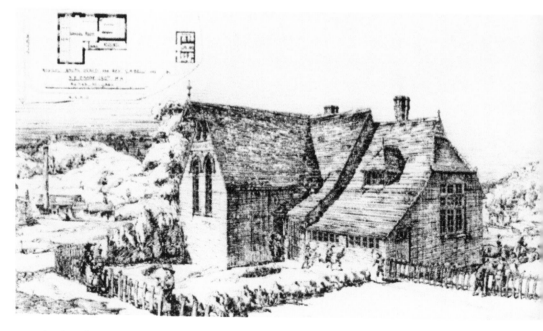

A print of an old school in Brentwood from 1786 showing a plan of the building.

taken place for eight years without the officers of the school being aware of it. Gillespie was sentenced to five years in prison.

At a later meeting of the Hackney Board of Guardians it was decided that Mr and Mrs Adwick would not be allowed to return to the school. The board also found that the school's committee and guardians had spent a lot of time at the school but had placed too much trust in the officers involved in its running. They also said that the use of corporal punishment should be decreased at the school.

DID YOU KNOW?

Fagging in schools was still commonplace in the early 1960s. The scheme seemed more suited to the nineteenth century, but it was obviously still going on at Brentwood School in September 1962. There was some attempt to bring the system into the modern age when Mr J. Rennie, a housemaster at the school, made fagging a voluntary activity. Mr Rennie felt that it was wrong to force younger boys to make tea and clean shoes for the older boys. Therefore, he was going to allow the younger boys to charge £1 a term for their services, but only if they wanted to continue with the scheme. There were reports that some boys were charging more than £3 a term, but he doubted if anyone would pay this much.

Shops and Businesses

In the mid-nineteenth century there were a large number of coaches travelling through Brentwood, mainly from the east coast to London but also from Colchester. According to Palmer these coaches were supposed to cover around 8 miles per hour but they normally managed around 10 so they could keep up with their timetable. Mail coaches were expected to travel 10 miles per hour so had to do around 11 or 12 to keep to their timetable.

Those from far away, such as Yarmouth, had two coaches, one travelling each way – Yarmouth to London and London to Yarmouth. Shorter routes, such as from Colchester, journeyed to London and back again in a day. When the railway came to Brentwood, coaches ran to the station from places the railway had still not reached.

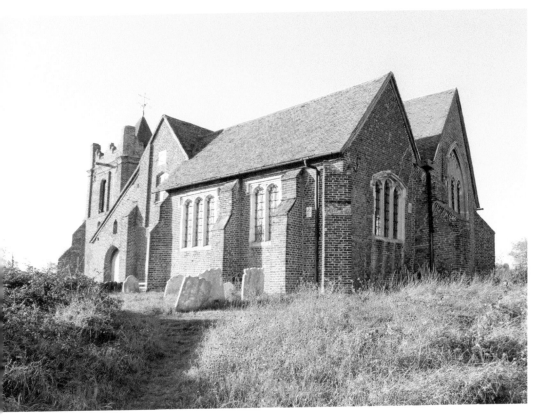

All Saints Church, East Horndon, dates back to the fifteenth century when it was built by the owners of Heron Hall. (Kyra Foley)

As well as coaches, wagons travelled through Brentwood from East Anglia three days a week. Some were so large that they had ten or twelve horses pulling them. Some wagons were bound for the town, such as one driven by a man named Wicker who would carry coal from Chelmsford. Coal was also carried to the town by a man named How using a donkey. Some farmers who carried hay to London also brought back coal with them to save returning with an empty wagon.

Coal began to be carried into the town on a more regular basis when the Brentwood Gas Light Co. was formed in 1836. The company supplied the town with coal gas from their gasworks at Crown Street. New works were built near the railway in 1858 so that coal could be brought directly into the works by train.

By the mid-nineteenth century Brentwood had several shops in the town. There were a few butchers; James Bell and Jake Offin were two of them – there were normally buildings at the rear of these shops where animals were slaughtered. Mr Thomson was the chemist and a Mr Treader was a watchmaker. Treader had formerly been a blacksmith but had become paralysed and did all his work in bed. There were also some grocers and a pig market was held on Shenfield Common on Saturdays.

A gravestone in All Saints Churchyard, East Horndon. The church closed at the end of the nineteenth century and although restored, it declined again, partly due to bomb damage. It is now closed. (Kyra Foley)

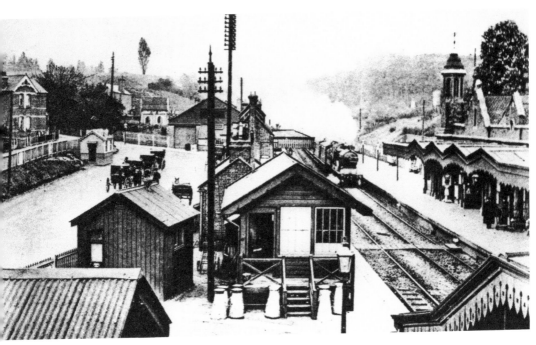

Brentwood station was the scene of some trouble between the navvies who built the line there in 1840.

The existence of banks was not widespread in the past and any banking was normally carried out by prosperous shop owners. In Brentwood Lemon & Co., a successful grocers in the mid-nineteenth century, performed this service. Unfortunately, like many other private banks, Lemon & Co. folded.

There was a proper bank in the town in 1873: the London and County Bank. When the Essex Bank came to Brentwood in 1883 there was a growth in business in the town, which must have been greatly helped by having suitable banking services.

Land enclosure was a regular occurrence in the past, but there were cases of parts of the Common being enclosed too. A shed was built in which pigs were kept, which Larkin described as an encroachment, but it had stood there long enough to become private property until it burnt down. There was also a cottage built and some land taken from the Common in the nineteenth century by pig dealers. The cottage later became a hospital until a new one was built in 1934.

During the nineteenth century many of the roads that existed in the town had a mixture of homes and shops. Old images of the town show this clearly. There were also probably as many public houses as there were shops in the town during the early nineteenth century. Many of the buildings at the west end of the High Street were lodging houses, where the navvies who built the railway stayed.

The town had a unique selling point in the early twentieth century when the photography company Ilford moved here. They had needed to move to somewhere with cleaner air, which was required to improve the photographic process, so they bought 8 acres of Warley Common and opened their new factory in 1904.

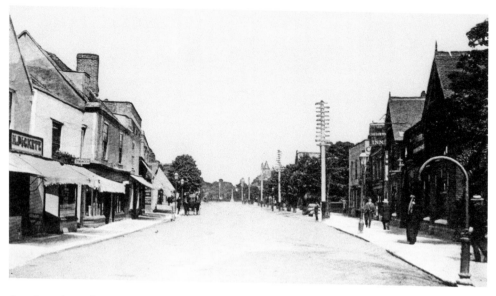

Another view of Brentwood High Street, which seems to have been a popular scene for old postcards.

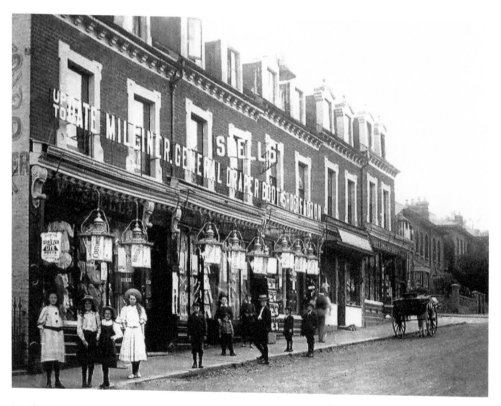

Warley Road. Once two separate villages, Warley and Brentwood expanded towards the station after it opened until they joined together.

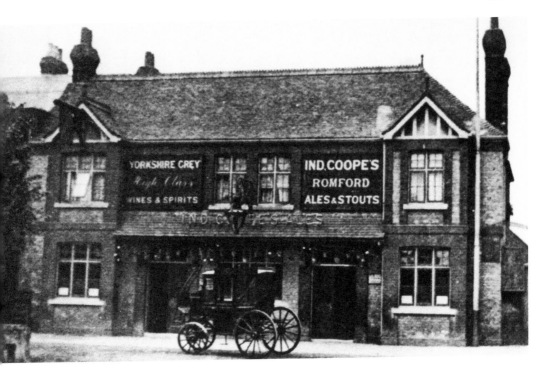

The Yorkshire Grey, another of Brentwood's old public houses.

The Manor was one of the houses that stood in the High Street until the early twentieth century when it was replaced with shops.

Crime

Robbery seemed to be quite a common crime in the Brentwood area in the early nineteenth century and was often serious enough to be reported in *The Times*. Unfortunately, they rarely revisited the story to mention the sentence the criminals received. In one case in October 1800, two men broke into the home of Samuel Byford in Navestock. They forced their way in and tried to get upstairs but Mr Byford closed a trapdoor, which stopped them. Many houses at the time had what was known as a Turpin trap (named after the infamous highwayman), which stopped an intruder getting upstairs if they managed to gain entry to the house. One of the men got a hand through the trapdoor so Byford cut it, after which the men left, taking some of Byford's belongings with them.

A mile from Byford's house (close to the Robin Hood & Little John Inn at Brentwood) Mr Mingay, a horse dealer of South Weald, was attacked by two men. The men demanded his money but Mingay, who knew the men, said no. The fact that the would-be robbers were known to their victim must have occurred to them as one of the men then said, 'Do you know me?' Mingay obviously denied that he did, so they let him go, taking

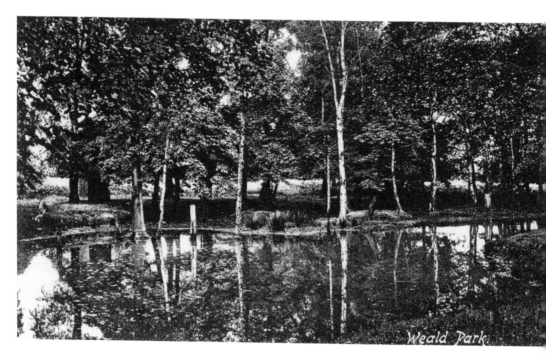

Weald Park, one of Brentwood's open spaces with a wide selection of wildlife, well used by locals.

£5 from him. Mingay later traced the men close to Billericay and saw them at The Bull public house. He seized one man but his accomplice ran out the back door of the building; however, he was caught just before he entered a wood.

When the criminals were taken before a magistrate they were suspected of being the same men who had burgled Mr Byford's house. Byford was sent for and found that one of the men was wearing his coat, which was identified by a hole in the pocket. One of the men also had a cut on his hand from when he had put it through the trapdoor.

In May 1819, Mr Hall, the officer of the Union Hall, was visiting Essex on business. After arriving at the Green Man Inn at Navestock, he was told that a poor labourer returning from a ploughing match had been knocked down and robbed of 9s. The victim, William Gentry, was aged around sixty. Hall learnt that the suspect was a most desperate character and was feared by the whole neighbourhood; he was known to have committed a number of robberies. Despite this, Hall went after the man single-handedly towards Pilgrim's Hatch. He apprehended John Fincham, alias Caskey, alias Buggy, and took him before the Revd Charles Towers of Brentwood where he was identified as the robber and committed to trial at Chelmsford.

There had also been an accomplice in the robbery named John Guy, so Hall went after him as well. He apprehended him at Croxley Green. When he took Guy before Towers he gave evidence for the Crown against Fincham, but was still committed to Chelmsford.

A print from 1888 of a house called the Thought Cot in Brentwood with a plan of the layout of the building.

Fincham admitted to up to twenty robberies in the past six months including the robbery of Mr Nash, the workhouse master at Navestock.

January 1820 saw an inquest held at South Weald under C. G. Parker, the coroner. On view was the body of James Mingay, who it appeared was not a person qualified to carry a gun for the purpose of killing game. He had been seen in Dag Wood near Doddinghurst at five o'clock on 29 December firing the gun he carried. He was approached by Colonel Hamilton's gamekeeper Edward Looker, who asked him what he was doing. Mingay replied, 'Keep off or I'll shoot you.' Looker then put his gun to his shoulder and fired both barrels at Mingay. Looker then said, 'If you move I will blow your head off.' Looker left him there and Mingay tried to get home but only got as far as Day's Farm, around a mile from Dag Wood.

Mingay was taken home to South Weald where a surgeon, Mr Butler of Brentwood, removed a bullet from and dressed his wound but told him that there was no chance of his recovery and sent for Archdeacon Woolaston, a local magistrate. He then issued a warrant for the arrest of Looker. When Looker arrived with the constable Mingay pointed him out as the man who had shot him.

Looker claimed that Mingay had pointed his gun at him, but Mingay claimed that was impossible as it was hidden under his smock. He also said that the gun was not loaded.

A print of Great Stonefords in Brentwood from the nineteenth century.

The Shen Almshouses are just over 100 years old and were built for those in Brentwood who could not afford their own house. (Kyra Foley)

Mingay then said that if the gun had been loaded he may have shot Looker. Mingay died the next day.

There was a quite clever crime that was committed in various London venues but was connected with the barracks at Warley in 1832. An Irish woman named Elizabeth Wellington was brought before Alderman Ansley at the Guildhall, charged with defrauding the chapelry of Bridewell of £10 11s 8d. The Beadle of Bridewell had brought the woman and two others to Chatham Place, where they applied with a pass for the payment of the usual mileage as part of a company of soldier's wives and children on their way to Warley.

They claimed that 18 women and 114 children who made up the rest of the group had gone ahead in a wagon as they were suffering from fever. The woman cried, claiming to have seen one of the children die and be buried. She only asked for payment for the women present and not those on the wagon, but the beadle misheard and paid her for all of them. The money was to be repaid by the government from excise.

When the receipt was presented to the excise office the clerk there discovered a similarity in the handwriting of the receipts from the overseers of Dartford and of Staines and in other receipts for £24. He concluded that these were forgeries. A few days later one of the women was apprehended while making another claim. The woman was recognised by one of the men who had paid her at another office.

The influx of large numbers of navvies to build the railway between Romford and Brentwood in 1839 must have caused some disquiet in the area of Brentwood. Their fears were justified in October when there was an attempt by two men to raise the wages of those working on the line, which led to a violent confrontation. John Bigsby and Thomas Hammond were indicted for trying to stop men working to raise wages.

Mr Burger, the contractor on the railway, said that he had to take steps due to the insubordinate conduct of the two prisoners and others. On 21 September a crowd of workers had gathered and refused to work for the 12s a week they were being paid – they wanted 15s. They threatened to knock the heads off anyone who would work for 12s.

One man, William Peters of South Weald, refused to listen to them and began to get his horses ready to go to work. The two men then assaulted him. John Curtis, another employee of the railway contractor, said that he heard Hammond threaten Peters and then saw them fighting. Hammond was sentenced to a month's imprisonment with hard labour. Bigsby received two months.

There was an unusual court case heard in March 1857 when two men who had been charged with manslaughter appeared in Chelmsford Court charged with assault instead. There seemed to be a great emphasis placed on how well dressed and how respectable the men were in the reports in the newspapers. Egmont Hoof and Albert Hoof had hired a stable from John George of Brentwood. They then lured George to the stable and spent time drinking wine with him. When George passed out, the two men covered him in red ochre and drew a line across his throat as though it had been cut, before pushing him home in a wheelbarrow.

George later died. The coroner found the reason to be natural causes but the local magistrate decided that the men should be charged with manslaughter, which is the charge they were bailed on. The judge decided that covering the man with ochre had been assault and that his death may have been partly due to the position that they had placed him in when they put him in the wheelbarrow.

The jury, though, found the men guilty of assault, not manslaughter. They had been allowed to stand on the floor of the court but when found guilty they were ordered into the dock. The judge said that the behaviour of the two men had been disgraceful and that pushing him along Brentwood High Street in a wheelbarrow had left him open to ridicule. He sentenced both men to a month's imprisonment. The defendants seemed very shocked at the sentence.

In December 1859 there were what was described as 'Wholesale burglaries' that were serious enough to be reported in *The Times*. The report said the town was attacked by burglars who entered the house of Mr Cordon, Mr Medway's counting house, Mr Proud's shop, The George & Dragon Inn, and the Lion & Lamb Inn. Several items were stolen including silver spoons, a coat and a large amount of money.

The report went on to say that after 1 a.m. every facility in Brentwood was vulnerable to housebreaking as it was at this hour that all public lamps were switched off. It was then considered that having the lamps burning to a later hour was a necessity as the cost would be a trifling addition to the present rate.

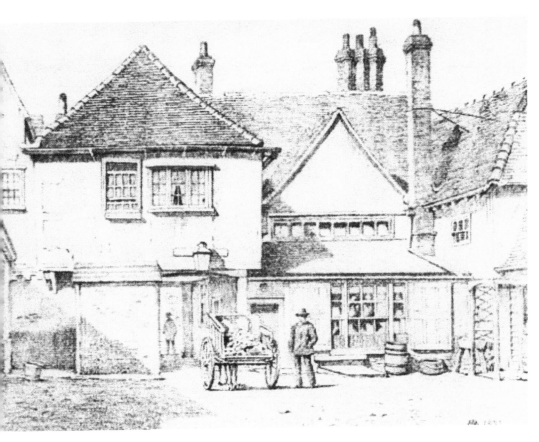

An old print of the George & Dragon public house.

It seems that whatever the result of the previous burglaries it did not stop them reoccurring. In March 1866 Alfred Greenhill was before the Brentwood petty sessions charged with being a 'wholesale burglar'. It seems that he had burgled four houses and stolen similar items to the previous report. He had also stolen a shotgun.

The addition of institutions such as the barracks and the asylum increased the level of crime committed in Brentwood. In June 1867 a murder took place in the asylum. One of the attendants had heard breaking glass at tea time on a Friday. He went into a dormitory and saw Joseph Weider, aged seventy-two, on his hands and knees on the floor. A patient named George Bloomfield was holding what was described as a chamber utensil – perhaps a chamber pot – and before he could be restrained he hit Weider on the head with it; it was evident that he had already been struck before this. When restrained, Bloomfield said he attacked the old man because Weider would have killed him.

Weider died a few hours later. Dr Gilland, the medical officer at the asylum, said that both men had been friends but had similar religious delusions. Bloomfield claimed that he heard voices criticising him. He was a forty-year-old stonemason and also suffered from fits. Weider had been a fisherman at Barking but had then distributed religious

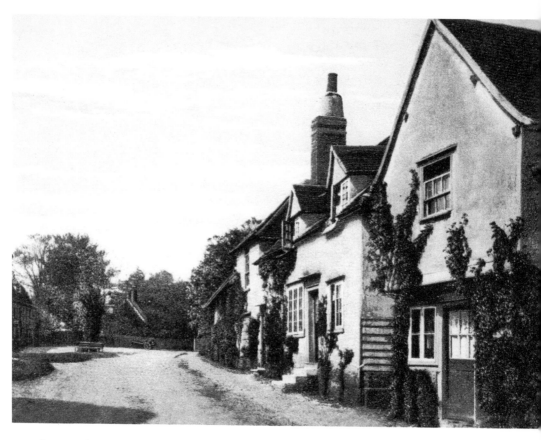

Great Warley, which has managed to retain its quaint, small-village atmosphere.

tracts in local villages. Bloomfield was found guilty of wilful murder and sent to the Chelmsford Assizes.

Another brutal crime was committed by a soldier at the barracks in March 1870. A sergeant of the 9th Regiment had been posted on the Isle of Grain but returned home to Warley and was unable to find his wife. He eventually located her in a beerhouse drinking with other soldiers. On the following Monday the man tried to cut his wife's throat. He managed to gash her neck but she ran out of the house, so he dragged her back and this time cut her throat fatally. He then cut his own throat and stood over her until he collapsed from blood loss. There were a number of men present during the events but none of them made any attempt to intervene.

The misbehaviour of men based at the barracks was, it seems, a regular event. In March 1884 James Cullen, a private in the Manchester Regiment, and Michael Lynch, a private in the Essex Regiment, were charged with stealing a quart of brandy from the George & Dragon Inn. Lynch was also charged with assaulting Police Sergeant Burrell. The two men had entered the George & Dragon and Lynch had taken a bottle of brandy from the bar. The landlord, Mr Mead, had followed the men into the yard and seized Cullen. He broke free but ran into a wall and smashed the bottle. Mead had, by this

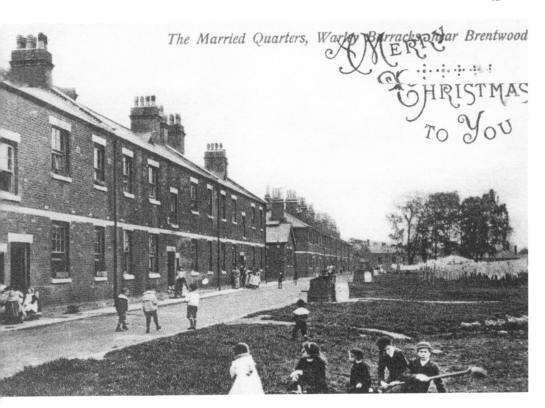

A postcard overprinted as a Christmas card of the married quarters at the barracks

The officers' mess at the barracks, which was more luxurious than the quarters for other ranks.

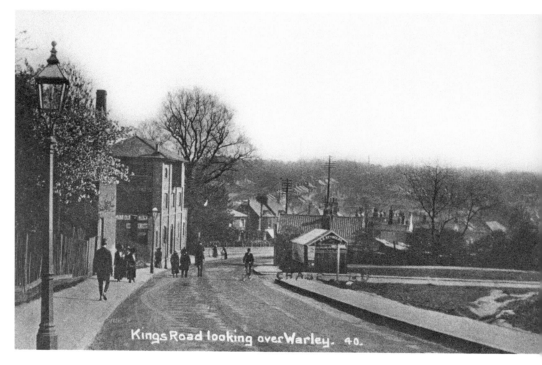

Kings Road looking over Warley. 40.

An early image of Kings Road looking towards the rural scene of Warley.

time, secured the help of Sergeant Burrell, who found Cullen hiding in a pigsty. When he arrested Cullen he was set upon by Lynch, who hit him with a stick on the head. Two more police constables then arrived and overpowered Lynch. The two soldiers carried on fighting, kicking and biting the police officers until locals arrived to assist them.

The situation became more threatening as other soldiers arrived on the scene and it looked as though they were about to rescue the two who had been arrested. Some of the older soldiers with them, however, persuaded the men to refrain from setting involved. The prisoners were removed to the police station where they continued to behave in a violent manner.

There were also times when the soldiers themselves were the victims of crime. This was the case in October 1887 when on a Saturday evening two young members of the 3rd Battalion, the Rifle Brigade, were returning from Brentwood to the barracks. They had reached Kings Road when they were set upon by six or seven Brentwood ruffians who knocked them about in a most brutal manner. One of the soldiers was left lying insensible in the road and spent some time after the attack in the barracks hospital. The attack led to unrest among the soldier's comrades and the following evening a large number of soldiers appeared in the town. A serious disturbance was expected but a strong piquet appeared and the evening remained calm. This was until the soldiers went looking for the perpetrators of the attack and found one of them in the Spotted Dog beerhouse. The attacker was severely punished by the soldiers and some damage was done to the beerhouse in the process.

DID YOU KNOW?

It was once illegal to ride a motorcycle faster than you could ride a pedal cycle. There was an unusual crime reported in the area in August 1901 when Mr G. A. Crackford of Ilford was summonsed for riding a motorcycle between Brentwood and Romford at more than 12 miles per hour. The police said that he had covered 6 miles in less than nineteen minutes.

It wasn't always soldiers from the barracks or the less desirable members of the local population that were responsible for crime in Brentwood. In December 1923 Mr Francis Harris of the Poplars, South Weald, who was a member of the Essex Union Hunt, was fined 20s for assault on Ross Allen, a local farmer.

On the day of the assault the hounds had gone through Brand's Farm and sometime afterwards Ross Allen had seen four horsemen crossing his fields in the opposite direction. He spoke to the horsemen at a gate as he was concerned about gates being left open – the foot-and-mouth order was in force at the time. Mr Harris then got into

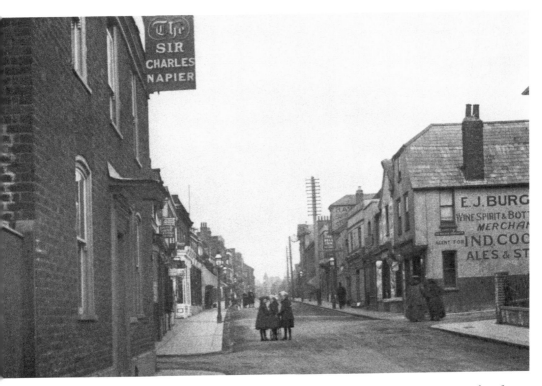

Another of Brentwood's many public houses, the Sir Charles Napier. Napier was the commander of the British Army in India, no doubt a connection with the East India Company.

a rage, rode his horse at Allen, struck him with a riding crop, and then hooked him round the neck with it. When Oswald Allen came along Harris knocked him down with his horse.

The struggle went on for some time between Harris, another of the huntsman and the two farmers. It was pointed out in court that Mr Harris was sixty-seven years of age and had hunted in the district all his life. He had offered to pay if he caused any damage. Harris claimed that Allen had refused to open the gate and had threatened to shoot him.

The idea of people being cheated out of money by what are now known as scams may seem a quite modern idea, but in August 1960 a Brentwood farmer was made an offer that sounded very risky. A letter was sent to Mr W. Alan of Langford Bridge Farm at Kelevedon Hatch offering him an African man in very robust and good health who came from Rhodesia. It seems that the African man would work on his farm for £5 a month plus room and board. The letter writer offered to pay the fare of the African to Brentwood but to cover his expenses he would expect Mr Alan to pay him £150 within thirty days of the man's arrival.

In August 1964 two men were charged with rustling. The farmer of Park Farm, Herongate, was alleged to have stolen eight Hereford Heifers worth £1,000 from a village

A nineteenth-century print of a room inside Chequers, which was a public house in the High Street.

The Adult Community College building was once the Hackney Training School. (Kyra Foley)

in Buckinghamshire. The stolen cattle were recovered from Park Farm. It turned out that there was another man involved who had driven a cattle truck to carry the cows. There were five other stolen cattle found in a road at Ingrave. The farmer, who was charged with the theft, said that the cows were all alone in a field and were asking to be stolen.

The Military

Although the camps and barracks at Warley are the better-known military establishments in Brentwood, it was actually Shenfield Common that had the earliest military connections in the town. In 1558 when Elizabeth I visited her army at Tilbury ready to face the Spanish Armada, the Earl of Leicester's halberdiers and a number of local Brentwood men gathering on the Common before marching off to Tilbury to join Elizabeth's army.

The military camps on Warley Common were regular sights in the eighteenth century. They were often used for training and were mainly occupied by militia regiments. In times of danger, such as in 1776 during the American Revolutionary War or during the Anglo-French Wars when there was a danger of a French invasion (such as in 1778), there would also be regular army units at the camps as well. When a large French army was assembled in Brittany ready to invade, Warley was chosen as a defensive site as the army could gather here and be close to any point where an invasion could occur.

An old print of the Warley Heroes from a pamphlet published to make fun of the old Warley Camps.

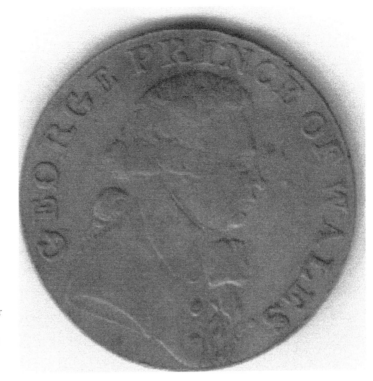

The 1794 Warley Halfpenny. It was common in the past for private businesses to make their own tokens used in place of scarce small change.

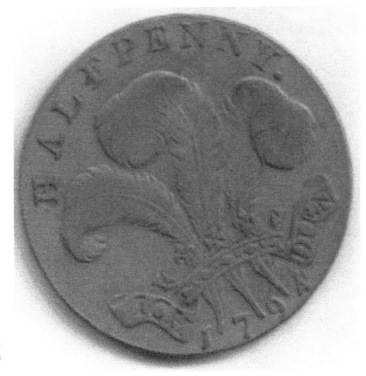

The other side of the Warley Halfpenny showing the emblem of George, Prince of Wales, whose bust appeared on the other side.

Warley Common was also once the site of a racecourse. As well as the followers of the sport of kings, others gathered to watch the troops. A mock battle was watched by George III and Queen Caroline at the camp. The camps became such a tourist hotspot that a number of inns opened in the area to cater for the visitors. The first inns had names relating to the racing, such as the Horse & Jockey and the Turf Tavern. They later took on more military-sounding names, such as the Soldier's Hope.

The camps were very large and in 1778 there were two main military camps in the country, one of which was at Coxheath in Kent. The camp at Warley included four regular regiments and eleven of militia. The number of men at the camp eventually outnumbered the population of Brentwood by more than ten to one. As well as royalty, another famous visitor was Ben Johnson. He visited the camp and spent a week staying in a tent with a friend who was an officer in the militia.

Some people were out to cash in on the soldiers' presence. Booths were set up selling food and anything else that a soldier may want. There was even a coach that left Warley at 5 p.m. for London, returning at 5 a.m., no doubt for those who required more than Warley could offer – this would only have been open to officers as less than a quarter of them actually slept at the camp.

The idea of the militia as a military force was not always taken seriously. George Huddesford wrote a satirical poem about the camp at Warley in 1778. It was called 'Warley a Satire Addressed to the First Artist in Europe'. It was printed as a pamphlet and cost 1s 6d. It stated that 'in the county of Essex north of Romford and neighbour to Brentwood, wild Warley's hillocks abound with banners and flags. Ten thousand brave fellows fatten in clover at threepence a day and a halfpenny over'. The food was also described as 'Thus Essex oxen are slain and of all thy green herbs only cabbage remain.'

This view of the men living in luxury was not shared by those at the camp, apart from maybe the officers. There was a serious disturbance at the camp in June when the men complained about the dirty black bread they had to eat. This led to the bread contract at the camp being reviewed.

Boredom at the camps seems to have been dealt with differently by private soldiers and officers, who had much more freedom. At the camp in 1793 a riot began just after the evening gun was fired. Several drunken members of the Cambridgeshire Militia were led by a sutler named Portells and tried to seize arms from one of the tents with what was described as 'mutinous intent'. Portells was grabbed by Lord George Cavendish, the colonel of the Derby Militia, and the guards were called out who arrested the ringleaders. It was not the only case of trouble within the Cambridgeshire Militia, who also got into trouble in Colchester. One has to wonder what the effects on the locals may have been if the militia had succeeded in gaining weapons.

Despite being a summer-only camp, they were run on strict military lines, at least for the enlisted men. In 1779 a number of deserters were caught and were sentenced to 1,000 lashes. Only around half the sentence was carried out before the men were taken off to hospital; completing the whole sentence would have proved fatal.

In the days before barracks were permanent, wives and girlfriends of the soldiers would follow their men wherever they went. This often included going off to war. There would

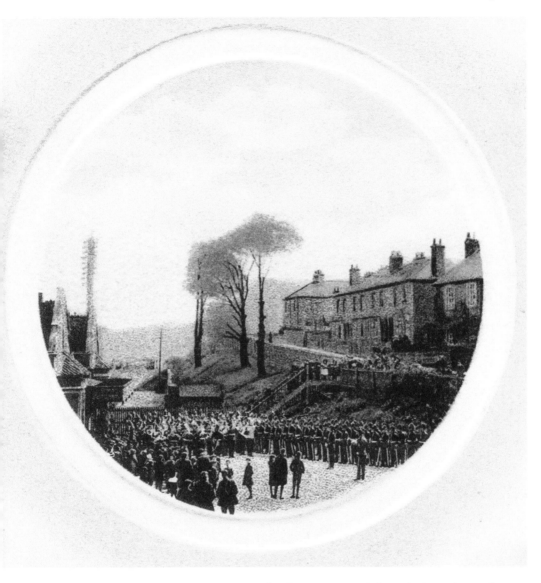

The army at Brentwood station. It was common for the men to march from the barracks to take trains to their next posting.

also be a following of prostitutes and no doubt this would have been the case at Warley when the camps were in place.

The ranks normally consisted of men enlisted from the rural labouring classes or criminals given a choice between joining the army or going to prison. Officers, however, came from a different class and being in the army did not interfere with their privileged life. Samuel Johnston mentioned this when he visited one of the early camps. He had noticed how the officers' quarters far surpassed those of the enlisted men.

ESSEX YEOMANRY

Nº 8. G.P. TERRITORIAL BADGES.

The Essex Yeomanry badge. The yeomanry were part-time soldiers who trained at weekends and at summer camps at places such as Warley.

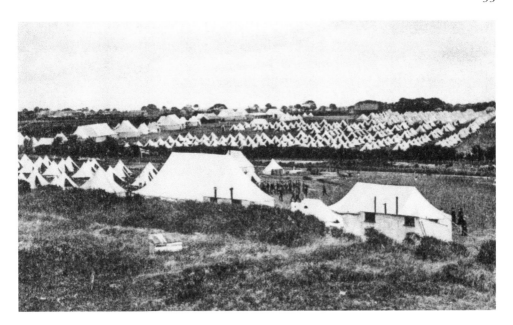

Military camps were common in Essex, especially in the summer for part-time soldiers, and tented camps were common to house recruits during the First World War.

DID YOU KNOW?

Officers in the army in the nineteenth century loved amateur dramatics. They would mix with the local nobility from both the early camps and later from the barracks. Local dramatic performances were held at the local inn, the Lion & Lamb. The *Beggar's Opera* was performed under the patronage of the officers from Warley camp and the role of Polly Peacham was played by a Mr Church. Officers of the Huntingdon Regiment took part in a version of the *Mountaineer*. Amateur dramatics was a popular hobby of the rich.

The lack of early barracks in England before the Napoleonic Wars was mainly due to public opposition to standing armies. There was always a suspicion that an army separate from the civilian population was in danger of being misled by commanders who had ulterior motives. Another view was that soldiers billeted in inns – which was common at the time – were too close to the temptations of civilian life. The first barracks in Britain were built in Scotland and Ireland in the eighteenth century, where secure bases were needed for what was essentially an army of occupation.

The camps at Warley eventually evolved into permeant barracks in 1805 when it was realised that barracks were needed in case of invasion. *The Times* reported how in October that year a special jury, composed of gentlemen belonging to the western division of

The Headley Arms, another Brentwood public house. This one is named after the landowning family who sold the land for the barracks to the government.

the county of Essex, met at Brentwood due to the sheriff's summons. This was to assess the sum payable to Lady Headley for her land on Warley Common, which had been appropriated by the government for the erection of artillery barracks and magazines. The jury decided that £5,000 damages should be paid to Lady Headley.

DID YOU KNOW?

In early military barracks such as at Warley, a large number of men had to share rooms, often more than one man in each bed. Six men per company were allowed to bring wives into the barracks and had to make do with a blanket as a screen between them and the rest of the men. This was known as the corner system and was criticised as indecent.

A year after the barracks were opened, Warley House was built on the corner of Eagle Way and Warley Road, which was to be used as the quarters of the commandant of the barracks. Many of the men from the barracks fought Napoleon across Europe and at Waterloo. At the end of the war the parish became responsible for many of the widows and children of the men who did not make it back.

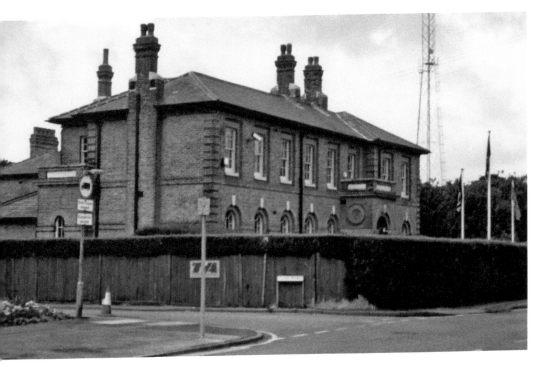

Building in Eagle Way that was once part of the barracks complex and has survived today.

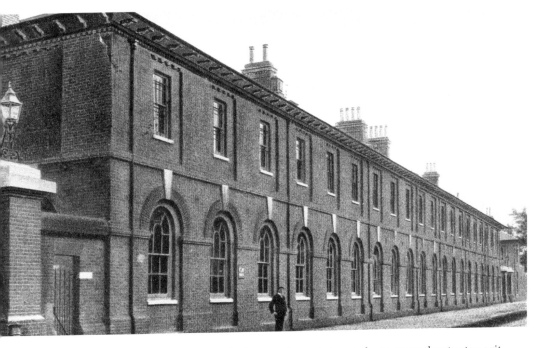

Part of the old barracks buildings. Notice the bars on the upstairs windows – were they to stop exit or entry?

The evolution from tented camps to permanent barracks did not curtail problems with the soldiers. In 1809 George Nelson, an artilleryman from the barracks, was charged with ravishing Elizabeth Pool, the wife of an ostler, at a Brentwood inn. It seems that Mrs Pool often went to the barracks selling small items to the men. After one of these visits Nelson followed her across the fields and attacked her.

Nelson was seen by a Sergeant Duncan and bombardier Roberts, who had pulled him off Mrs Pool. Nelson then made out to be drunk but Sergeant Duncan doubted that he really was. Nelson was found guilty of the attack and transported for life.

In 1844 a young man named Mark Crummie tried to join the 4th Dragoons. He wanted to join the cavalry so he could wear a blue coat, not a red one, and went to the rendezvous in Westminster to enlist; however, he found that the Dragoons were no longer enlisting. Instead, he was offered the chance to join the East India Company army Flying Horse, who also wore blue coats. Mark was given a shilling and sent to the recruiting office in Soho Square, where a magistrate swore him in. He was given 7s 6d and another half a crown once he passed the medical. A £4 bounty was also payable when he reached Warley. On the way he passed a pub in Brentwood called the Soldier's Hope with a life-sized picture of an artilleryman on a signboard outside. The pub was run by former Sergeant Major James, who had served in the Bombay Foot Artillery.

Warley Barracks came as a shock to the recruits. The civilian clothes they arrived in were taken away and sold – there was less chance of desertion if the soldiers had to run away in uniform. Most of the sergeants at the barracks were pensioners from the regular army. The men spent much of the day drilling, then in the evening they would go into Brentwood and visit the pubs.

The soldiers at the camps and barracks were welcome customers for the locals. In 1844 a tender was put forward by Thomas Stone of Herongate offering to supply the barracks with 56,000 lbs of straw for 2s 7d per hundredweight. A Peter Aspin of West Tilbury sold 400 tons of coal to the barracks for 28s per ton.

Despite the income the barracks may have brought to the town, there were problems with the army using local amenities. In 1844 four soldiers from Warley were awaiting trial in the local prison at Chelmsford. This was already overcrowded with civilian prisoners, so they were sent to Colchester.

In 1842 the barracks were sold by the government to the East India Company, who were expanding their operations. They paid £15,000 for the barracks and many of the men based there were then sent to India; however, not all of them arrived there. In 1844 seventy-one artillerymen, ten sappers and miners and twenty-five infantrymen from the company barracks set sail for India from Gravesend. They were on a ship named the *Diamond* bound for Bombay. The ship hit a sandbank in the Thames, which was quite common at the time, and managed to refloat but then hit another. By this time the ship was badly damaged and the men were returned to Warley.

The name Warley became well known throughout India as all recruits were given a chest to keep their belongings in, which became known as the Warley Box. It wasn't very secure as all the locks opened with the same key. The officers in the company army were recruited on a cadet system and often arrived in India untrained.

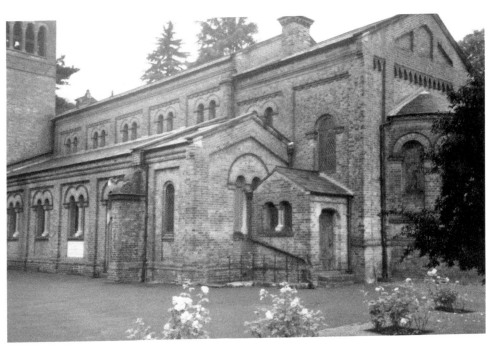

The barracks chapel. This is another part of the barracks that has survived demolition.

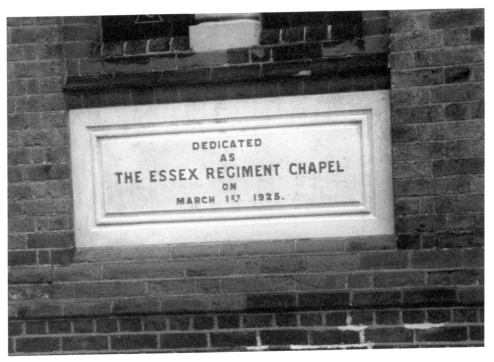

Dedication stone set into the chapel wall stating that the building became the Essex Regiment Chapel in 1925.

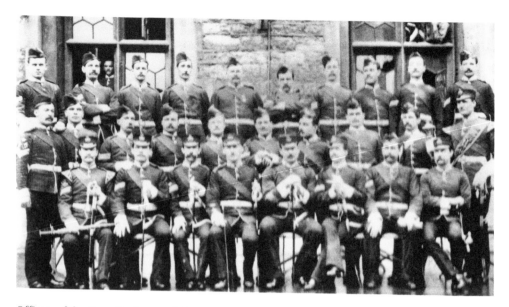

Officers of the Essex Regiment. Although often based at Warley, in this image they are at the Tower of London.

The local government of the period when the company owned the barracks tried to take advantage of the fact that it was privately owned by trying to get them to pay rates for the local Poor Law, which the regular army did not do. The Poor Law Commissioners at Somerset House were contacted and said they were unaware of any exemption to the rates by the company.

In 1846 the directors of the East India Company came to Warley to inspect the troops. Large crowds turned out to watch them as they arrived by train and then took a carriage to the barracks. After inspecting the troops they dined with the officers from the barracks at the White Hart in Brentwood.

The company army grew to around 150,000 men and began to play a part in the wars between the small states in India after the Mughal Empire broke up. After the Indian Mutiny the government began to send regular troops there, so there was less need for the East India Company to have its own army. As well as this, George III was not happy at the idea of a private army that was not under government control. In 1861 the barracks returned to the ownership of the government. Warley then became closely associated with the Essex Regiment.

The Essex Regiment were based at the barracks when they were ordered to depart to Africa to take part in the Boer War in 1899. They were commanded by Colonel T. E. Stephenson. In 1903 they were back, and marched through the county to attract the attention of the locals and enlist recruits on the way. In December that year Sir Evelyn Ward unveiled a memorial in the Warley garrison chapel to the 209 men of the Essex Regiment who died in the Boer War.

The confinement of men at Warley Barracks was a regular event. In 1898 three men had escaped from the guardroom by smashing a hole in the outer wall. The same thing happened again in 1900 when three members of the Essex Regiment, being held for various reasons, escaped by breaking through the outer wall. Privates Hodge and Warman escaped in civilian clothes. They had been returned to the barracks by London police as deserters.

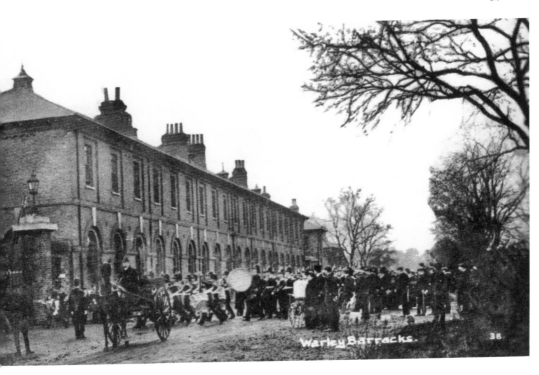

A military band entering the barracks and attracting a large crowd of spectators.

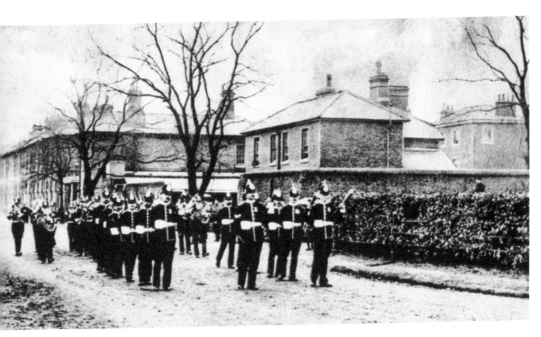

A military funeral at the barracks. Men serving in the army did not only die at war. Sickness was often present in crowded and unhygienic barracks.

Private Denham was in uniform and had been confined to the guardroom over some matter within the barracks. Denham gave himself up soon after escaping, while the other two men evaded sentries by playing hide and seek in the open ground around the barracks.

There was a local incident involving a balloon in 1910. Captain Maitland and Captain Disney of the Essex Regiment were based at Warley when they decided to make an ascent in a hot-air balloon. They left from the barracks intending to land further along the River Thames, but they got lost in thick fog and so tried to put down, hoping that they were still in Essex. They came down in the Thames Estuary and the balloon began to sink. They then threw out an anchor, which caught on the shore. Two boats put out to rescue them but by this time they had thrown out all excess ballast and the balloon had taken off again. They eventually landed at Cliffe on the Kent shore of the Thames.

There may have been balloons over Brentwood in the past, but not like the ones seen over the town in May 1915. Zeppelins were reported in the area, and according to *The Times* there were a number of fires spotted locally too, but there was no proof that the fires had been caused by bombs.

There were attempts to provide an interesting and respectable pastime for the large number of soldiers that arrived at Warley during the First World War. The British Women's Temperance Association opened a soldiers' institute in Warley Road to provide writing material, games and refreshments under the charge of the Revd R. Whittleton. No doubt this was an attempt to keep the men out of the local pubs.

It wasn't only the local ladies and the clergy helping out during the war, the nobility also helped. Lady Petre started a milking school at Thorndon Hall,: her country home. In all, eighty-five children attended the school and went on to help out at local farms where manpower was in short supply. Lady Petre also did her bit helping out at a recruiting

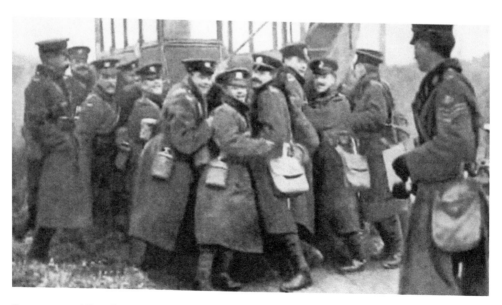

Buses carry soldiers from Warley during the First World War.

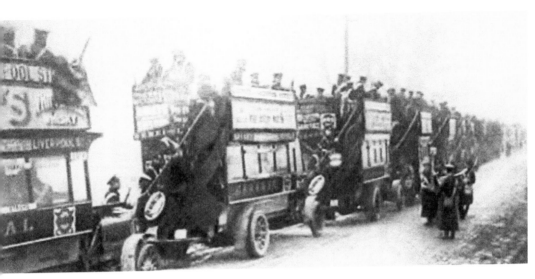

Some buses used to carry troops were painted in plain colours. These still have advertisements on them.

rally in Brentwood, but this was for women for the Land Army. Mrs Crawshaw helped Lady Petre organise the rally. There was a guard of honour on the station platform of Girl Guides. Outside the station there was a guard of honour of Boy Scouts. A procession of farm vehicles and carts, decorated and carrying banners encouraging recruitment, were ready to travel through the town. A cortege of the Women's Land Army, Boy Scouts, Girl Guides, children from the Poplar Training School and the band of the Essex Regiment led the vehicles along King's Road and through the High Street, attracting the attention of locals as they passed.

Not everyone residing at the barracks wanted to be there. In August 1916 Private Clifford Allan, former chairman of the No-Conscription Fellowship, had refused to serve in the army or even take a medical, but he was passed fit and posted to a non-combatant unit. He still refused to serve, and claimed to be a socialist, believing in cooperation between nations.

Allan was court martialled at the barracks on a charge of refusing to tidy his cell. He complained about the composition of the court as it included Lieutenant L. Blumfield, who was the son of the editor of the *Daily Express* – the newspaper had been very critical of conscientious objectors. Allan also asked for Bertrand Russell to be present at the trial. Allan was sentenced to one year's hard labour.

The barracks were already in place when the First World War began but they were never going to be able to hold the number of men needed to fight in Europe and beyond. A camp was set up on Shenfield Common and soldiers were billeted in many of the houses in the town. A number of the large houses in the town were used as hospitals to treat the wounded, and the war itself did not entirely miss the town as a bomb fell on Shenfield. During the war a number of the guards regiments were based at Warley. The Prince of Wales had arrived at the barracks in 1914 to join the Grenadier Guards.

IN SUPPORT OF THE

WAR
LOAN

(By Government Request)

WILL BE HELD IN THE

TOWN HALL,

BRENTWOOD,

ON

Monday Afternoon Next,

FEBRUARY 12th, 1917,

AT 3 O'CLOCK.

— —

SPEAKER:

HERBERT BROWN, Esq.

SUPPORTED BY

Rev. C. F. Newton; Rev. W. Legerton; Very Rev. Dean Norris; Major Gardner; Major Maunsell, J.P.; J. J. Crowe, Esq., J.P.; J. H. Horton, Esq., J.P.; Geo. Hammond, Esq., J.P.; and others.

The government needed money to pay for the war and this was helped by towns collecting and lending money for the war effort.

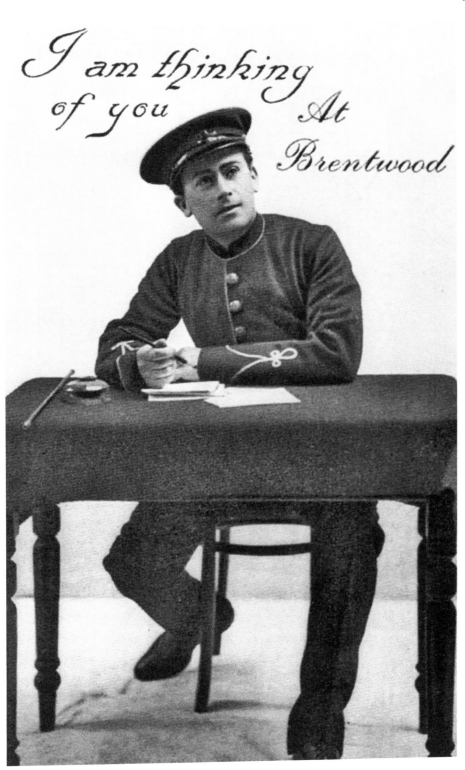

I am thinking of you At Brentwood

A soldier deep in thought as he writes a letter, maybe to a loved one from Brentwood.

Black market dealing went on between the soldiers and the local population during the First World War. The *Barking, East Ham & Ilford Advertiser* reported on several men who had bought items from soldiers at the barracks and ended up in court. Ernest Brown of Brook Street was fined 20s for buying two cardigan jackets from a soldier. At the same hearing John Ouley, also of Brook Street, was fined half a crown for unlawfully receiving two blankets and an overcoat from soldiers at the camp. Private Thomas Bradbury was remanded in custody for stealing five 1-lb packs of butter, which he had made into parcels ready to be posted.

The barracks had a number of visitors during the war, including Lord Kitchener. He came to inspect the Irish Guards in January 1915 and became their honorary colonel. The men were also visited by the Bishop of Chelmsford, who spoke to the men in the camp chapel the month after Kitchener.

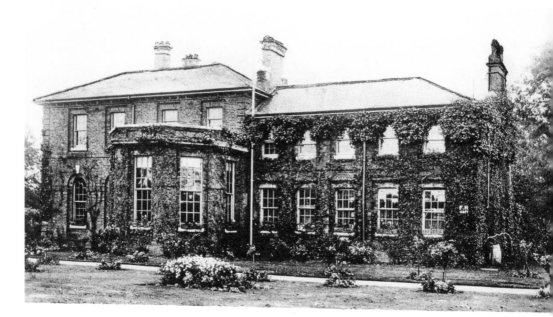

The officers' mess at the barracks, which was situated further along Eagle Way from the main barracks.

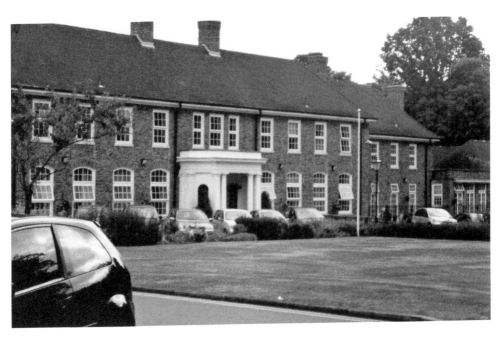

A modern view of the old officers' mess, which has survived and is now a care home.

Not everyone from Warley Barracks made it to the battlefields of France, such as the three members of the Irish Guards training there who died in an accident. A rifle grenade had been fired but did not explode. It was then replaced on a rifle to fire again but this time it exploded while still on the rifle. As well as the three deaths several men were injured, but the man holding the rifle escaped unharmed.

The after-effects of the war were often contested by the government. On the proposal of the Minister for Pensions, the government had considered the cases of ex-servicemen who were now mental patients. It seems that under the terms of the Pensions Act the charge for these men was not met by the Board of Pensions more than one year after the end of the war; the government had decided that after a year their mental condition was nothing to do with the war. The government had, however, decided that the cost of keeping these men in mental institutions would, in future, be met from a special grant, which would then remove them from the ambit of the Poor Law. This decision seems to have been brought about due to a former serviceman who was a patient in Brentwood Asylum, and Mr George Lansbury MP described it as a great victory. The Poplar Guardians had refused to pay for the man's treatment in Brentwood. They would have been fined in order to meet the cost of the man's care if they carried on refusing to pay. A deputation from Poplar had gone to see the Minister of Pensions and it was after this that the government brought in the new arrangements.

The Second World War was to have huge impact on Brentwood. After Dunkirk the country was seen to be in danger of invasion and Essex was thought to be one of the main sites under threat. A number of defensive lines were built in the county to be held by the army if there was an invasion. Brentwood did not stand on one of these lines but it was

Grand Victory
TATTOO

By kind permission of Lt.-Col T. E. HEARN,
Officer Commanding No 1 I.T.C.

TO BE HELD ON

Wednesday, Thursday,
Friday and Saturday,

at 9 p.m.

JUNE 19th, 20th, 21st & 22nd, 1946

at Warley Barracks.

IN AID OF THE
ROYAL FUSILIER & THE ESSEX REGIMENT
REGIMENTAL ASSOCIATIONS AND WAR
MEMORIAL FUNDS.

Programmes - 3d. each.

H. G. ALLIS, PRINTER, BRENTWOOD.

Programme for a Victory Tattoo held after the end of the Second World War.

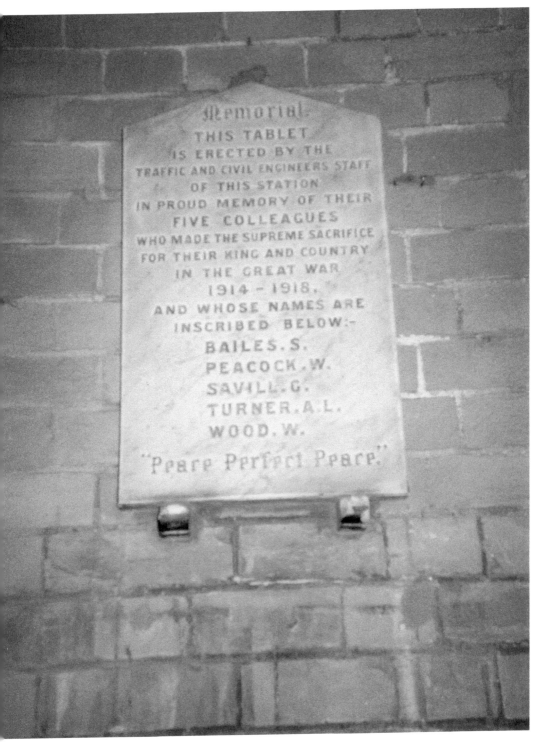

A memorial tablet on the wall of Shenfield station with the names of the railway staff that died in the conflict.

Local company Hudson of Kings Road advertised in the Tattoo programme for developing photographs of the event.

later decided to include town defences here. In Brentwood and Shenfield this included a number of concrete and steel road barriers, which were later reinforced with the Spigot Mortar. These were meant to be held by the Home Guard. The cable and wireless radio station at Pilgrim's Hatch also had a regular army guard and pillboxes. Weald Park was used for training by the Essex Home Guard and there were large numbers of men living there in tents while training.

Very few of the Second World War defences remain. There is a pillbox on the site of the old radio station, a small wartime building and a small bunker. There are some Spigot Mortar placements remaining in the borough, and there are also some hut foundations in Weald Park. The barracks were used during the war to train new recruits. They were also to be the home of members of the Dutch resistance who trained there. The 2nd Battalion of the Essex Regiment had left the barracks for France on 1 September 1939 but were soon back as they were part of the force evacuated from Dunkirk.

Spigot Mortars were used by the Home Guard in the Second World War to guard road junctions and vulnerable points if there was an invasion.

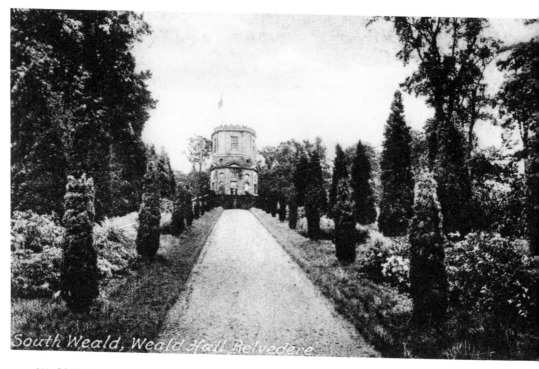

South Weald, Weald Hall Belvedere

Weald Park was once the grounds of Weald Hall. Much of the gardens were laid out by Capability Brown. The Belvedere Tower dated from 1900 but has since been demolished.

A serious criminal case took place during the war when a local Brentwood man, who worked for Vickers, was reported to have tried to sell plans to the Russians – an offence despite the fact that the Russians were allies. The man was tried at the Old Bailey and sent to prison for three years.

It is often said that community spirit was at its highest during the Second World War and that everyone helped each other out whenever possible. I have read quite a number of accounts that don't quite align with this view. One family who moved from Romford to Brentwood moved all their belongings in a handcart; among the belongings was a young child. The landlady of the room they moved into in Brentwood did not like children, so they had to keep her presence a secret. Another child describes hiding under the bed any time someone knocked on the door, as no children were allowed in the rented room in which he and his parents lived.

A different scenario occurred when children were evacuated to areas 30 to 50 miles outside of London. Those children who couldn't stay with relatives were sent away with their teachers. They were given free rail tickets and the householders who took them in were paid 3s a week if they were under fourteen years of age.

Some people were happy to help anybody who was suffering, one being Mrs Hollick of Dacre Cottages in Noak Hill, who helped a man who knocked on her door one day at 5.30 a.m. The man was wounded and Mrs Hollick helped him on to the sofa. The man

Pillboxes were built in many areas to protect military sites and other important positions during the Second World War.

turned out to be a German, the only survivor from a Dornier bomber shot down in Harts Wood, Brentwood.

There was what must have been an unusual event at Warley Barracks when a member of the Home Guard was court martialled. The man had been found unfit for long marches and had lost his temper and insulted the Court Martial Board. He was charged with using insubordinate language to an officer and was sentenced to twenty-eight days' detention.

It is often forgotten how primitive living conditions were during wartime. One Shenfield resident remembers that there was no running water in the house. They had two buckets: one for washing water, and the other for boiling clothes. The toilet was in the garden and was alive with rats at night, so instead of going out they used chamber pots, which were kept under the bed.

After the war the national servicemen who trained at Warley Barracks would march from them to Brentwood station. Many found much better accommodation in the barracks in Germany. By the 1950s the Warley Barracks had partly reverted to its origins, and many of the men based there found themselves in tents.

In 1958 the Essex Regiment became part of the Anglian Regiment and Warley stood empty for some years. Most of the buildings were demolished after the barracks closed in 1960. One of the wooden buildings was sold to Ongar Scouts and it was dismantled and rebuilt in Ongar. The regiment chapel has survived, as has one of the gymnasiums. Much of the land was later built on by the Ford Motor Co.

Soldiers from the barracks working on vegetable plots after the end of the war.

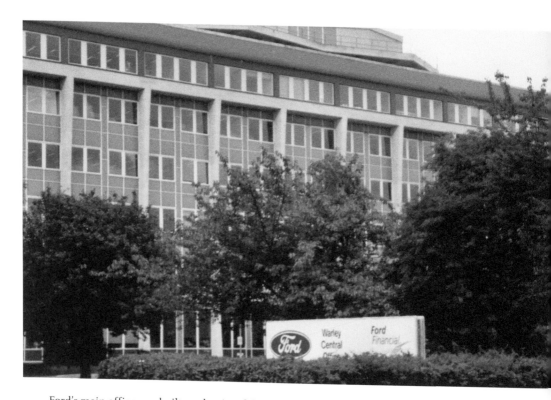

Ford's main office was built on the site of the barracks.

Local Events

An early local event held on Shenfield Common was the Artichoke Fair, held every Whit Monday. At such events a number of activities took place that have since fallen out of favour, such as badger-baiting and cockfighting. There would also be prize-fighting and wrestling. At one fair Lord Petre offered a purse of several sovereigns to any man capable of beating the bareknuckle champion of South Weald.

The Times reported an event that attracted a great deal of attention in May 1787. A grey mare belonging to a gentleman from Stoke Newington was the subject of a bet for a 100 guineas. The bet was that the horse could trot from Whitechapel Church to the 15-mile stone from London at Brentwood in an hour. Large numbers of spectators lined the route and the challenge became the subject of numerous other bets. The mare achieved the task in fifty-nine minutes and thirty seconds without breaking into a canter.

National events in 1821 were to have an effect on Brentwood after the death of Queen Caroline. The queen was loved by the public while the king, George IV, was hated. Her funeral procession was to go to Harwich where a ship would take her body to her native Brunswick. The planned route was to miss out London as it may have led to unrest, but crowds of people blocked the route so that it had to pass through the city. There was indeed trouble and the military escort opened fire on the crowds, killing two members of the public.

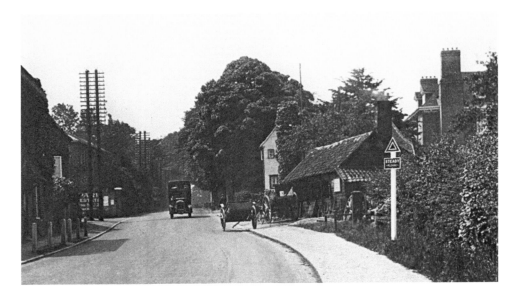

An old image of Shenfield High Road.

The funeral procession arrived at Romford late in the evening and it was thought that the body would lay in the church overnight. Instead, the procession carried on and once outside Romford the military escort went so quickly that they left the hearse behind. According to *The Times* the people of Brentwood had given up on seeing the funeral procession that evening. When it did arrive, it caught them by surprise. Many locals had a great desire to touch the hearse as it passed.

There is little evidence of ancient settlement around Brentwood, although there have been claims that the area was the site of a battle between locals and the invading Romans. In January 1832 some evidence of Roman occupation was found. Two men were digging on the high mounds of Warley Common when the earth suddenly gave way beneath them and sunk around 2 feet. According to *The Times* the men feared that the day of retribution had arrived and they 'fled like dust before the wind'. They soon recovered though and returned, carrying on digging to find a deep well encircled by bricks and containing a number of human skulls, bones and pieces of armour. The bricks appeared to be Roman, as did the armour. *The Times* report went on to say that it was known to historians that Warley Common was once a Roman encampment. It was therefore supposed that there was a decisive battle fought there. The well, or hole, had no doubt been a place for water in time of emergency but was afterwards converted into a burial place for the dead. Perhaps the claims of a battle being fought there may have some truth in them.

An old image of the Thatcher's Arms in Great Warley, which dates back as far as the fifteenth century.

Another old image of the Thatcher's Arms public house, which would no doubt have been used by men from the old military camps.

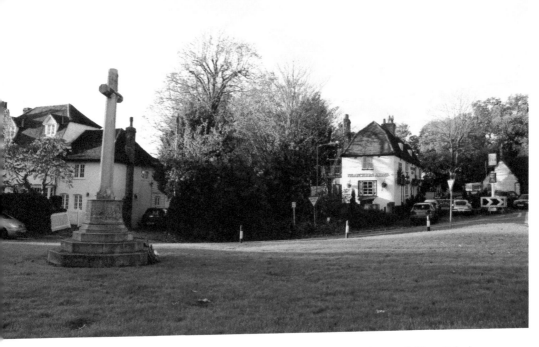

The war memorial at Great Warley with the Thatcher's Arms in the background. (Kyra Foley)

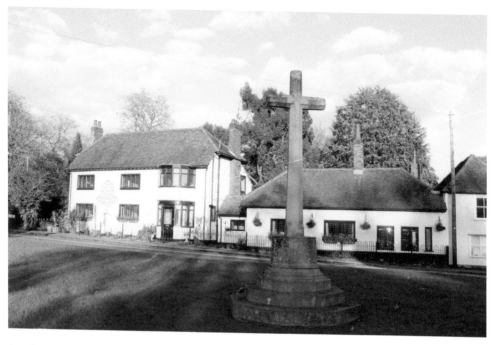

Another view of the war memorial at Great Warley. (Kyra Foley)

A new form of transport was to arrive in Brentwood in 1835: ballooning. Balloon ascents were popular at the time, not only for pleasure but also for scientific research, and many aeronauts took several instruments with them to measure temperature, air pressure and other information about the atmosphere. There were several pleasure gardens in London that offered balloon rides as part of the entertainment.

There was a report in *The Times* in 1835 concerning a monkey named Jacopo from Surrey Zoological Gardens, which were, in their time, a rival for the zoo in Regents Park. Jacopo was sent up in a balloon with ballooning pioneer Charles Green and made a widely publicised parachute jump out of it. He landed in the garden of a publican in Walworth. A reward of £2 and free entry to the gardens was offered for the animal's return. The balloon, with Green still on board, then came down in Brentwood.

In 1836, one gentleman arrived in Brentwood in a most unusual manner. The Duke of Brunswick was making his first flight in a hot-air balloon and ended up falling out of it near Brentwood.

There is little doubt that the duke was a rather unusual person. A few months previous he had paid a large amount of money for a seat at a public execution in France. He then murdered a machinery master at a Paris theatre. It seems that the man had moved part of the scenery while the duke was making love to an actress behind it. The duke never saw the funny side of the joke and ran the man through with his sword. No action was taken against him, no doubt due to his being a royal of Europe.

The duke was carried in his balloon by a female aeronaut called Mrs Graham. Mr Graham, who was also an aeronaut, was supposed to follow in another balloon,

but with no way of steering them this didn't happen as planned. The balloon had set off from Flora Gardens, Bayswater, in London, and the duke had been warned about how cold it would be so wore a heavy overcoat. Perhaps if Mrs Graham had known more about the duke she would have thought twice about taking him as a passenger.

Mrs Graham didn't want to go too high due to the unpleasant effects of high altitude, but the duke insisted on throwing out most of the ballast, which meant they went higher than planned. He then tried to get Mrs Graham to throw out all the ballast as he was disappointed when the balloon began to descend. This was later explained in a letter the duke wrote in which he stated that he wanted to rise so high that he could no longer see the ground. It is thought that the duke may have tampered with the valve on the balloon. They then came down much faster than planned and when the balloon hit the ground the duke fell out.

The duke claimed to have fallen 18 feet, but witnesses said it was only 9 feet. Mrs Graham, worried that he may be hit by the grapple used to catch hold of the ground, leant over too far and also fell out. The duke said she fell from a much higher position and he thought that she was dead at first. A local farmer, Mr Amor, and his men carried the unconscious Mrs Graham to Converse Farm – the duke made his own way. A surgeon was sent for and Mrs Graham, who had been pregnant, lost her unborn child.

According to a statement from Mr Graham printed in *The Times*, the duke had got out of the balloon in perfect safety but the loss of his weight had caused the balloon to rise up quickly and Mrs Graham, believing that the grapple hook was secure, fell out from a great height.

Marygreen Manor stands on the site that has been occupied since the twelfth century. It has had a variety of names in that time and was once known as the Moat House. (Kyra Foley)

The duke was quick to write his own account of his flight, which he sent to London as well as informing those waiting for the balloon's return. As the balloon had been expected to return to Flora Gardens at 5.00 p.m., there was much concern by midnight when those gathered to see the return were still waiting. He said he was sorry about Mrs Graham's injuries but seemed more worried about the loss of his coat and telescope, which had been carried off in the balloon after the passengers had fallen out.

Around a week after the accident a statement from Mrs Graham herself appeared in *The Times*. She explained that she had already ascended on five occasions and was the first British female to ascend alone in a balloon. She also mentioned that on one occasion, at the coronation of the king in 1830, she had taken off from Green Park and landed in the grounds of Lord Petre in Brentwood, so she had been not unfamiliar with the area.

Mrs Graham confirmed what her husband had said: that the duke did not fall from any height but stepped safely out of the balloon as it touched the floor. To try and stop the balloon ascending too fast Mrs Graham had let go of the ropes to release some air from the valve. She fell from around 1,000 feet but her dress acted as a parachute and slowed her fall.

A farmer named Mr Amor saw her fall and turn over a number of times in the air. Mrs Graham was conscious until she hit the ground and said she expected to die. She lay at the farm of Mr Amor for two weeks and was visited by her husband and relatives. It was only her family who contributed to her expenses. The duke had, on the day after the accident, paid Mr Graham the fee for the flight and did not offer to pay any more towards her expenses.

There was a report in the *Essex Standard* in July 1839 entitled 'An Invitation to the Brentwood Bazaar'. The bazaar must have been something special as it read:

Up and stirring – the bells are ringing, the children are calling Papa and Mamma. The morning has dawned and the birds are singing, haste, and haste to Brentwood and attend the bazaar. See the stalls all ranged and the bright eye of beauty beams gladness on hundreds that flock from afar. Here pleasure is wreathed with the dictates of duty and lends its effulgence to gild the bazaar. Clear the roads stand aside - see the crowds are advancing - I hear the loud shout and the cheering buzz. The steeds as if proud of their riders are prancing and the coach's bowl fast to the brilliant bazaar. And why tis the hand of religion that beckon'd and as wise men were led to the Syrian Star. Shame light on the man who could to be second when a halo divine hovers o'er the bazaar.

The coming of the railway had a huge impact on Brentwood, as it did across the country. Until 1840 all transport had been horse drawn. However, one major problem that railway builders faced was that an enormous cutting had to be made in the land. There was also a large bridge needed so that Seven Arches Road could cross the track. This was the Seven Arch Bridge, which still stands.

As was common with the coming of the railway in many places, the huge task led to the arrival of large numbers of navvies who would set up their own camps to live on the site or stay in local lodgings until the work was completed and then moved on. The navvies were not the only people attracted by the railway. There was an enormous expansion of the town as large numbers of new houses were built around the station.

Right: The Seven Arch Bridge, built to carry a road across the deep cut made for the railway line.

Below: A modern view of the Seven Arch Bridge, the view now obscured by trees.

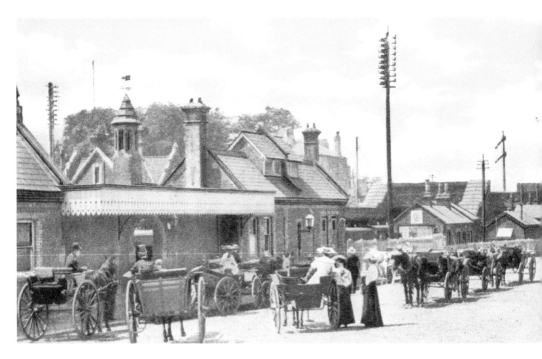

Brentwood station. As the horse-drawn transport shows, this image dates from the nineteenth century.

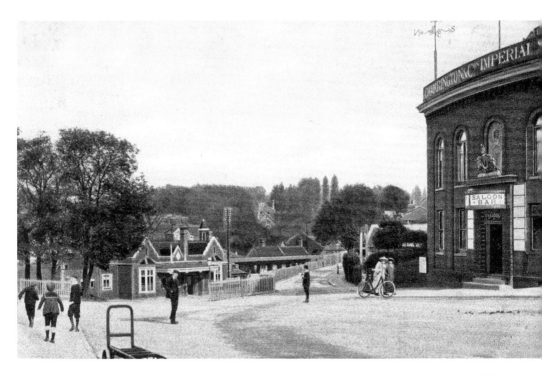

Another old image of the station, which shows the route towards Warley to be quite rural still.

The coming of the Eastern Counties Railway may have brought prosperity to the town but it also brought danger, as the railway in the nineteenth century was not a very safe form of travel: it was possible to buy insurance for a railway journey when you bought a ticket as accidents were so common. It didn't take long before there was a serious accident at Brentwood, in August 1840.

At 7 p.m. a train consisting of four first-class coaches, two second-class coaches and two third-class coaches, along with two trucks carrying stagecoaches – the Norwich Times and the Colchester Defiance – and eighty-five passengers left Brentwood station. Foster, the engine driver, quickly raised the speed of the train to 60 mph.

Around 2 miles from Brentwood the train began to warp so the passengers were certain that there was going to be an accident. The engine came off the rails and turned over as it fell around 10 feet down a bank, taking the coaches with it. It was only the two trucks carrying the stagecoaches that stayed on the tracks. The four first-class coaches were smashed to pieces and the second-class ones were badly damaged, burying many of the passengers.

A policeman on duty nearby raised the alarm and a number of workmen and local residents came to help. Nine of the passengers were seriously hurt and another had been crushed to death. The dead man was named Eastman and he was a labourer for the railway company who had been travelling in a tender next to the engine with the guard. The injured were taken to local inns, where it was suspected that there would be more fatalities.

When the chairman of the rail company Mr Bosanquet examined the crash site he said that it was evident the accident had been caused by the reckless racing of the engine driver. Drivers had been warned by officers of the company about exceeding a certain

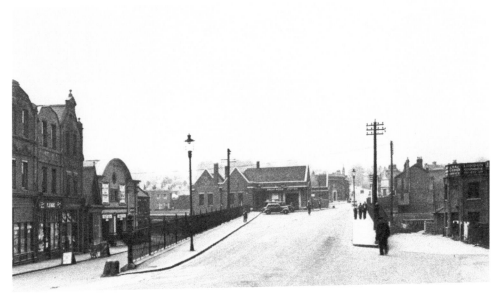

Another more recent view of the station showing that the area around it has become more built up.

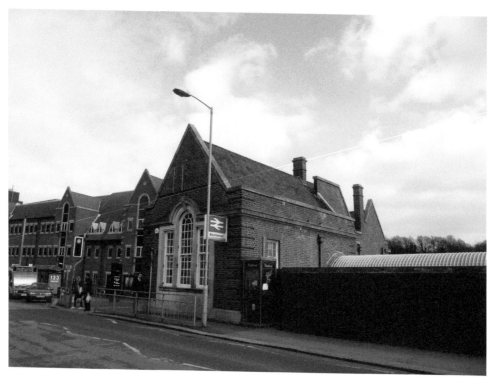

A modern view of the station with newer buildings now replacing some of those in the previous photographs.

speed and it was unaccountable how they could do this when their own immediate destruction stood staring them in the face if they did so.

Eventually the total number of deaths stood at four as three more of the injured died, and at the inquest one juror claimed that the line at Brentwood was not fit for public use, there having already been twelve or thirteen fatalities in the area. It was also said that the Eastern Counties Railway had said that they would not pay the deodand.

A deodand is a forfeit given to God, specifically an object or instrument, in law, an object or instrument that becomes forfeit as it has caused a person's death. This could be a horse, a carriage or a railway engine and the item or a fine equal to its value would be forfeit to the Crown. The money would then be used to apply some pious use. This system had been in force since the eleventh century but in recent years the money had normally been awarded to the families of the deceased, and at the inquest it was stated that the deodand, if paid, would be paid to the widows of the deceased. The deodand system was ended in 1846 when there was a sudden rise in the number of lawyers offering to claim damages after accidents, especially those occurring on the railways.

There seemed to have been a number of fires in the town in the nineteenth century, perhaps due to some of the older building being built of wood. In June 1843 a policeman on duty at midnight saw smoke coming from the house of Mr Thurgood, an upholsterer, followed by a woman coming out of the door shouting 'murder' and 'fire'. The policeman

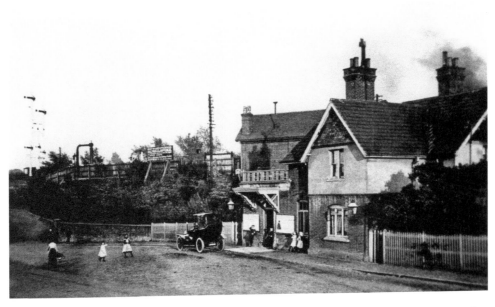

Shenfield station opened in 1843 when the line from Brentwood was extended to Colchester but closed in 1850 due to lack of use. It reopened in 1888.

A modern image of Shenfield station. It has been rebuilt since the previous image.

went into the house and roused the sleeping occupants. The parish engine arrived and Mr Moull of the White Hart sent messages to all the other local fire offices.

The Economic engine left Chelmsford at around 3 a.m.; the Ongar and Ingatestone engines arrived very quickly. A large detachment of troops of the East India Company also arrived from the barracks to help. The Romford engine was late as the person who was responsible for the horses was ill. There was a shortage of water and one engine had to be used to fill a vessel that other engines could draw from. The house was totally gutted but the engines managed to stop the adjoining houses from suffering too much damage – there had been a danger of the fire spreading to the rest of the town as the houses were so old.

A number of other accidents occurred on the railway at Brentwood, but the most serious happened in September 1850. George Kirby, a foreman for the Eastern Counties Railway, was on the engine of a train. He said it was a foggy morning and the visibility was no more than 40 yards. The train left Ingatestone just before eight o'clock and travelled at around 25 mph until they reached Shenfield. The train's whistle was sounded as they passed Shenfield station, as they passed under the two bridges and again when they saw men on the track and at the Seven Arch Bridge. The train was travelling at around 8–10 mph as the fog had gotten worse. The breaks were applied when the driver saw a group of men on the tracks.

The men on the track had been laying ballast and the driver of the ballast train had heard the approaching passenger train's whistle and called to the men to get off the line, but he didn't think that they heard him. He saw the passenger train knock one man down against the step of his ballast engine and saw the train run over some more men. Nine men were killed in the accident. The driver said that the noise of his ballast engine would have stopped the men on the line hearing the approaching passenger train.

The ballast train driver said he was unaware if the passenger train driver had been informed of the ballast work taking place. A number of the men who had worked for other railway companies said that they had a system where drivers were warned of work taking place on the line. A spokesman for the Eastern Counties Railway said that this was also done in relation to repairs being undertaken on the line but not in relation to ballast work, which seems quite strange as the men were still working on the line.

Parliamentary elections raised a lot of interest in the town. During the election of 1874 the intensity of feeling between the supporters of the Liberals and the Conservatives became so fierce that shopkeepers were forced to put their shutters up early. Two local men stood in the High Street fighting, each supporting their own choice of party, and watched by a large crowd.

While this was going on a German band marched into town – quite common in the country at the time. The Liberals hired the band to play at their headquarters at the Lion & Lamb. No doubt the peaceful name of the inn was not reflected in local feeling. When the band marched past the Conservative White Hart, they were set upon and had their instruments smashed, with the Liberal supporters following them. The fight ended with the Riot Act being read to those involved.

Funeral ceremonies often drew the attention of some local residents for reasons other than mourning. If the deceased had suffered from an interesting disease, their remains

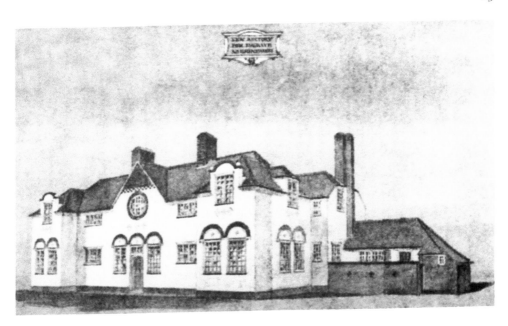

The rectory at Ingrave, near Herongate.

were desired by the medical men of London. The men who would procure the dead bodies for doctors were known as bodysnatchers, which was not always a full-time occupation. When trade in other professions was slow, grave robbing was often a viable alternative. This would lead to the family of the deceased watching over the graves until the body was no longer in a condition that made it suitable for examination. On one occasion at South Weald Church watchers fired a blunderbuss from the church porch, scaring off the grave robbers who left the body half out of the grave.

In June 1883 there was another serious fire in the town. It broke out in the centre of the High Street in the previous premises of Parr the ironmonger, at the time being used as a bank. It was feared that the local fire service would be unable to deal with it and that much of the High Street was in danger. The fire was first spotted at around 11.30 p.m. The man who had seen it ran to the police station and they sent a message requesting the two fire engines kept at the Town Hall at this time. By the time the police woke the tenants of the adjoining houses, the buildings were already full of smoke and had begun to burn. The building where the fire began was entirely made of wood and the fire spread quickly. An engine from the barracks worked by soldiers was also present on the scene.

The house in which the fire had begun eventually collapsed, which left a fire break between it and the buildings on one side. On the other side the fire had spread to the next building, but the soldiers from the barracks climbed on the roof and sprayed their hoses down onto it. The fire was brought under control by the early morning.

Another fire occurred after this in December 1883 – also in the High Street. It was in the house of Mr Winter, a builder. He was roused by a crackling sound and went downstairs to find the house engulfed in flames. He raised the alarm and the police arrived, helping to get his children out of the house. The engine arrived quickly and was operated by

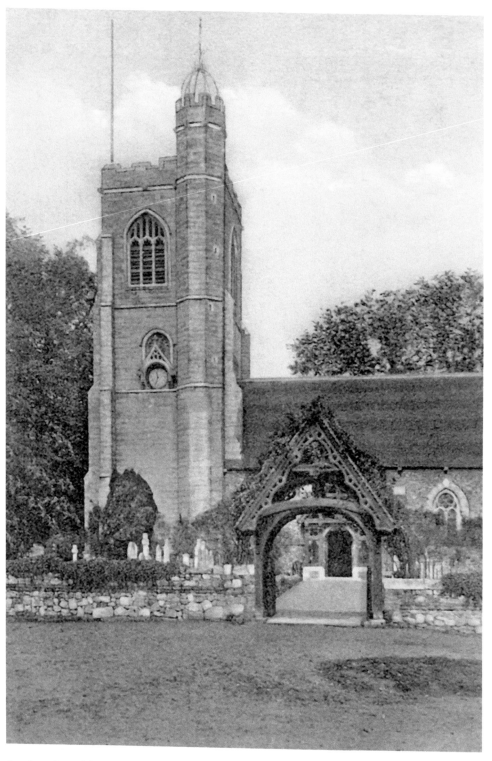

Another view of the church at South Weald where the churchyard was plagued by bodysnatchers.

firemen Andrews and Robson. The police helped to get the families out of the houses on either side of the burning building. The fire was mainly in the rear of Mr Winter's house and it took some effort to get the hose round to the back. After around three hours, and after one of the fireman climbed a ladder and poured water through the roof, the fire was brought under control.

As the nineteenth century drew to a close there was a new mode of transport becoming popular among all classes of the population: cycling. There were numerous cycling clubs and large groups of cyclists would descend on country areas from the more built-up towns at weekends. There was even a cycle shop in the town by the turn of the century. However, the new craze did not come without some danger, as was seen in Brentwood in July 1899.

Miss Celia Davies of Warley Road, Warescot, was described as well known and respected in the area. She had been returning from South Weald Church with her sister by cab but they got out at the station and walked up Warley Road. To avoid some tar paving being carried out they stepped into the road to walk around a cart that was parked there. As they did so Miss Davies was struck by a bicycle travelling very fast down the hill.

The cyclist was Private William Considine of the 1st Essex Regiment. He was thrown violently off the cycle and sustained extensive superficial injuries. He was taken back to the barracks and detained in hospital for some time. Miss Davies had come off worse: she was picked up by Mr Edgar Edwards of Warley Road and taken to her home, where Dr R. W. Quennell attended. Despite his attentions Miss Davies died the following day.

A serious event occurred in Brentwood in September 1903 that was local in character but was part of a much wider movement at the time. There was a passive resistance movement among those who were refusing to pay the portion of the poor rate related to education and the opening of a voluntary elementary school run by the Roman Catholics and the Church of England. Around twenty passive resisters living in Brentwood and the surrounding area had their goods sold in an auction at the White Hart Hotel to raise the money they owed. Several policemen were present at the auction and although there was much badgering and booing, there was no active disorder. The goods sold were only to raise the amount related to the educational portion of the rate. There was some complaint about the expenses incurred, which were often more than £1, though the amount owed was only a few shillings.

In November 1926 there was a gas explosion in which two men were killed. *The Times* reported that it took place at Brentwood but it was actually at Ingastone Gas Works. Both men, however, were from Brentwood. They were Mr Walter March of St Peters Road and John Griffin of Gasworks Cottages.

The two men and one other had been fitting a meter at the gasworks. They had fitted a valve at the back of the meter and were making a connection to the gasholder. The third man present, William Ellis, left the building to get some tools and then ten minutes afterwards the explosion occurred, wrecking the building. He was around 6 feet away from the explosion and was thrown against a wall, rendering him unconscious for around fifteen minutes.

Mr Early, the Brentwood Gas Co. inspector, said that the explosion was a mystery and the only people who could explain the cause had died. There had been a brazier at the end of the building where the explosion took place, but the whole building would have had to be full of gas for that to have caused the accident; however, the men working at

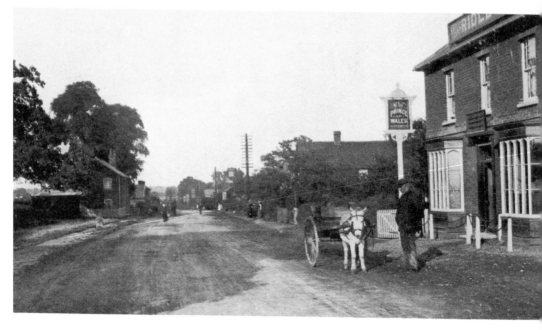

Ingastone, where the fatal explosion at the gasworks took place.

the gasworks had a keen sense of smell for any gas that was leaking, so surely they would have smelt this. Mr Ellis confirmed that there had been no smell of gas and that none of them had been smoking.

Brentwood is not somewhere you would expect to see air crashes as it is not very close to any airports. In April 1928 an aeroplane was in a night-time flying operation. This was in cooperation with the Essex Group Searchlight, so the aircraft was being followed by six searchlights on the ground. While it was being followed, the aircraft began to fall from the sky. The pilot Sergeant Trout jumped out of the plane with a parachute at around 2,000 feet and landed on a railway embankment. The aircraft struck a tree and was smashed to pieces upon landing in a meadow at Brook Street.

Sergeant Trout was found by a railway signalman who had seen the parachute drift in front of the windows of his signal box. Trout, unconscious, was carried inside and later taken to Brentwood by a train that had stopped at the signal box. He later recovered and was taken to the aerodrome at North Weald and was apparently uninjured. The crash was seen by many local residents who had been watching the searchlight exercise.

There was another accident involving an aircraft in May 1937, when a chemist from Dalston named Mr Douglas Charles Gee fell from a dual-control aircraft that was flying at 2,000 feet. The aircraft had taken off from Maylands Aerodrome, Romford, with Gee in the rear seat. The second man on board, in the front seat, did not notice anything was wrong until he landed.

Gee had fallen from the plane and landed by the side of the railway track, a short distance from Brentwood station. A number of people waiting for a train on the platform saw him falling to the ground. The body was removed to Romford.

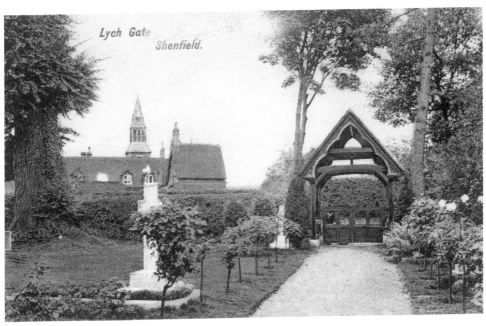

The lychgate at Shenfield. The lych was where those carrying a body to the churchyard would shelter.

St Mary's Church at Shenfield dates back to the thirteenth century when Shenfield was just a small village.

BRENTWOOD ELECTRIC PALACE,

HIGH STREET.

Resident Manager Mr. S. V. WILSON.
Continuous Performance 5.30 to 9.30. Matinee, Thursday and Saturday at 2.30. 'Phone 64.

SPECIAL !

THURSDAY, FEBRUARY 24th,

Albert Chevalier & Florence Turner
IN
MY OLD DUTCH.

Seats may be booked by 'phone between 10.30—1 and 5.30—9.30.
x24-33

An advertisement for the cinema in Brentwood during the First World War. It is interesting that tickets could be booked by telephone as they must have been quite rare at the time.

In May 1933 there was a royal visit to Brentwood when the Princess Royal laid the foundation stone of the new Brentwood District Hospital. As well as a number of local dignitaries, there was also an honour guard of the Voluntary Aid Detachment and the Girl Guides in attendance. Also present was the man who had donated the 18-acre site for the hospital, Mr P. A. Bayman.

DID YOU KNOW?

In 1934 a policeman chased a stag on his bicycle down the High Street. Police Constable Smy first saw the stag jump over a hedge in Western Road and run towards the centre of town. He gave chase but could not catch it as it ran down the High Street, through the traffic and turned into the grounds of a school. By this time a large crowd had gathered and followed PC Smy. The crowd followed the stag towards the railway line before it turned and headed back towards the High Street. It leapt over a stationary car and crashed straight through the window of a car showroom next to the White Hart Hotel. One of the car salesmen lassoed the stag, which had come from Weald Park. After being examined, it was found to be so badly injured that it had to be shot.

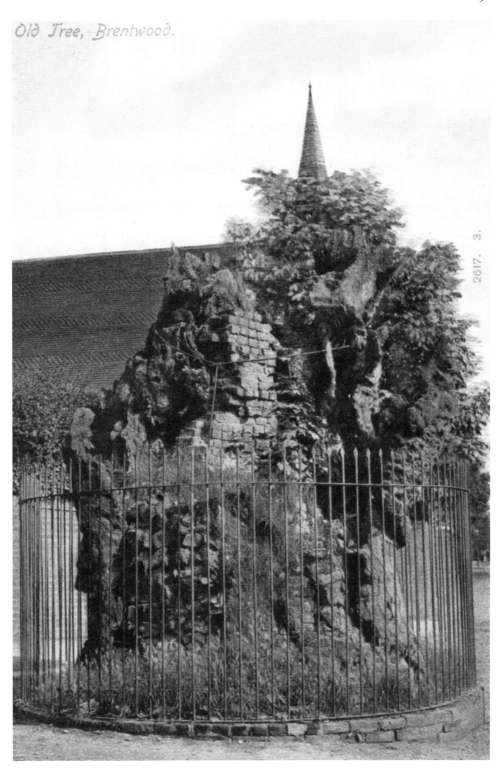

The Old Tree, Brentwood.

The people of Brentwood who were spending a pleasant evening at the cinema in January 1957 must have got a bit of a shock. Marlon Brando was on his knees before Miss Jean Simmonds during a showing of *Guys and Dolls* at the Palace Cinema when the characters began to speak in Italian; they continued to speak and sing in the language for ten minutes.

The manager of the cinema, Mr Sedgwick, said that they did not get the film until late so there was no time for a rehearsal. MGM's dispatch department said it was the first time this had happened in twenty years and a special messenger was sent with a new reel of the film. They said that the missing English reel of the film must have gone to Italy.

In February 1963 Brentwood Council planned to obliterate a traffic bottleneck at the junction of Kings Road and High Street, but the plan was seriously delayed because the council could not agree on it with the Ministry of Transport. The council wanted the ministry to buy a property that was once a clubhouse and hall, which would then be demolished to allow for road widening. The ministry said that they would only buy half the building because they did not want to own more land than they needed to. The decision was described as farcical at a council meeting. The ministry said that they wanted to knock half down and shore up the rest, so the council suggested buying half the building each.

An unusual event reached the local press in the early 1970s when events at the Prince Albert public house on Warley Road aroused interest. It started when an American report on the dangers of smoking cigarettes was published, which led the landlady, Mrs Joan Newman, to take action. Mrs Newman was smoking sixty cigarettes per day and suggested to one of her regular customers that they should take up smoking a pipe instead of cigarettes. The next day both of them turned up smoking pipes. This was soon followed by six more women. The new habit was so popular that Mrs Newman was going to ask the manufacturers of pipes to produce lightweight pipes for women.

Bibliography

Bean, E., *A Historical Sketch of Sir Anthony Browne's School 1557–1913* (1913).

Clamp, F., *Brentwood: Our Heritage* (The History Press, 2010).

Green, M. (ed.), 'Eleven O'clock Sept 3 1939' (Stylus Press, 1977).

Hearn, M., *A Gypsy Childhood* (Hearn, 1995).

Linnecar, P. (ed.), *Fireside Talks About Brentwood 1906* (Sharon Publications, 1989).

Nash, F., 'A Survey of World War Two Defences in the Borough of Brentwood' (Essex County Council, 1999).

Palmer, G., *A History of Coaches.*

'Record of Mark Crummie' in *Essex Review*, Vol. 55 (Benham & Co., 1926).

Wakeford, E., 'The Day the Duke Arrived by Air' in *Essex Countryside* (November 1964).

Ward, G., *A Brentwood Surgeon* (1967).

Ward, G., 'Brentwood Women's Riot in 1577' in *Essex Countryside* (July 1961).

World Sports Magazine (April 1959).

Also available from Amberley Publishing

MICHAEL FOLEY

BARKING & DAGENHAM

THROUGH TIME

This fascinating selection of photographs traces some of the many
ways in which Barking & Dagenham have changed and developed over
the last century.

978 1 4456 0240 0
Available to order direct 01453 847 800
www.amberley-books.com

Also available from Amberley Publishing

MICHAEL FOLEY

LONDON'S EAST END

THROUGH TIME

This fascinating selection of photographs traces some of the many ways in which London's East End has changed and developed over the last century.
978 1 4456 0513 5
Available to order direct 01453 847 800
www.amberley-books.com